# Cool Restaurants
# Rome

teNeues

# Imprint

| | |
|---|---|
| Editor: | Eva Dallo |
| Photography: | Roberto Pierucci |
| Consultants: | Doriana Torriero, dorianatorriero@tiscali.it |
| | Valentina Pedroni Nayar |
| Copyediting: | Alessandro Orsi |
| Layout & Pre-press: | Emma Termes Parera |
| Translations: | Wendy Griswold (English), Martin Rolshoven (German) |
| | Michel Ficerai/Lingo Sense (French), Maurizio Siliato (Italian) |

Produced by Loft Publications
www.loftpublications.com

Published by teNeues Publishing Group

teNeues Publishing Company
16 West 22nd Street, New York, NY 10010, USA
Tel.: 001-212-627-9090, Fax: 001-212-627-9511

teNeues Book Division
Kaistraße 18, 40221 Düsseldorf, Germany
Tel.: 0049-(0)211-994597-0, Fax: 0049-(0)211-994597-40

teNeues Publishing UK Ltd.
P.O. Box 402, West Byfleet, KT14 7ZF, Great Britain
Tel.: 0044-1932-403509, Fax: 0044-1932-403514

teNeues France S.A.R.L.
4, rue de Valence, 75005 Paris, France
Tel.: 0033-1-55 76 62 05, Fax: 0033-1-55 76 64 19

teNeues Iberica S.L.
Pso. Juan de la Encina 2-48, Urb. Club de Campo
28700 S.S.R.R., Madrid, Spain
Tel./Fax: 0034-91-65 95 876

www.teneues.com

ISBN: 3-8327-9028-4

Bibliographic information published by Die Deutsche
Bibliothek. Die Deutsche Bibliothek lists this
publication in the Deutsche Nationalbibliografie;
detailed bibliographic data is available in the Internet
at http://dnb.ddb.de.

| Contents | Page |
|---|---|

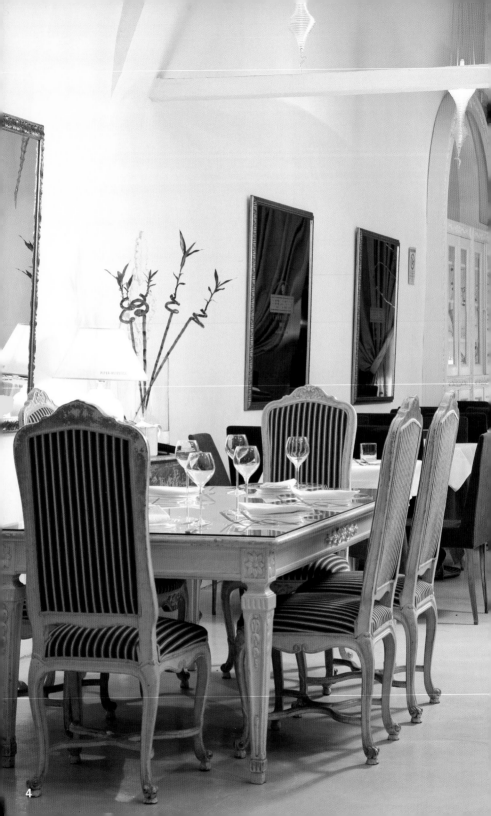

## Introduzione

Roma è nota anche col nome di Città Eterna, come se fosse stata lì dall'inizio dei tempi. Un'impressione che si accentua passeggiando lungo le sue strade suggestive, piene di tesori artistici e costruzioni millenarie. A Roma si respira un'atmosfera tutta particolare – e a dirlo non sono solo i suoi abitanti – che più di una volta strappa a molti visitatori un sincero: "proprio come nei film!"

Roma infatti è come si vede nei film: risulta colorista e smisurata, irresistibile e seducente, dall'aria un po' teatrale, nobile ma gioviale, orgogliosa del suo incommensurabile patrimonio storico-artistico. Una città i cui abitanti passeggiano tranquilli e sicuri di sé, consapevoli del peso di una cultura classica non indifferente.

Roma (e l'Italia, in genere) non ha inteso la modernità come sostituzione degli elementi già esistenti, bensì come una forma nuova di risaltare e accentuare ciò che è classico, introducendo concetti di arte e cultura contemporanei che contrastano, rivalorizzano e aiutano a capire meglio il passato.

Così come accade in altri aspetti della cultura, il rinnovamento ha coinvolto pure l'ambito della cucina romana. La ricchezza di materie prime e le sperimentazioni condotte nel corso dei secoli hanno dato vita a delle autentiche pietre miliari – la pasta, il riso, alcune tecniche di cucina – che figurano tra le basi della gastronomia universale. L'inestimabile tradizione culinaria che da sempre vanta Roma viene costantemente esplorata, ma non trasformata, con approcci di tipo avanguardista, e arricchita di ingredienti sempre nuovi che ne aumentano le sue infinite possibilità. La modernità e la tradizione si fondono armoniosamente non solo a tavola ma anche nell'arredamento dei locali: il loro design non segue pedissequamente le mode del momento, ma cerca di risaltare con originalità lo spirito romano. Negozi di prodotti italiani si trasformano in ristoranti, pasticcerie offrono la possibilità di consumare pasti o cene, locali famosi decidono di rinnovarsi, dipingono le pareti di un altro colore e risistemano, in un altro ordine, i quadri, le fotografie, e i ritagli di giornale che le coprivano; ancora un'altra testimonianza del prestigio e dell'originalità della cosiddetta tradizione romana.

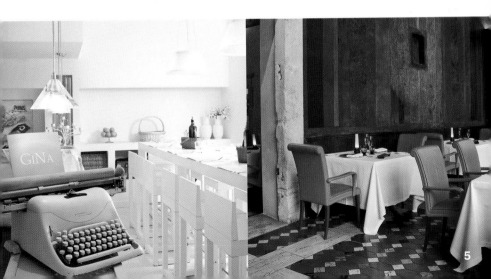

# Introduction

Rome is known as the Eternal City, and it does seem as though it's always been there an impression that is reinforced as one wanders through its streets, where thousand-year-old art and architecture are ubiquitous. Conscious of its cultural importance, its citizens revere the city and find satisfaction in being Roman, creating an atmosphere so much its own that many visitors feel that "it's just like in the movies!"

And, in fact, Rome is just like in the movies because, as on film, it's colorful and overwhelming, overpowering and seductive, exuding a certain theatrical quality, perhaps because of the almost patrician attitude of its inhabitants, proud of a city known the world over, with vast historic value; its citizens are at peace, sure of themselves, aware of the importance of such a significant classical culture.

Rome (and Italy in general) does not see modernity as a renewal or replacement of that which exists, but as a new way of bringing out and accentuating that which is classical, introducing contemporary concepts of art and culture that contrast with, reassess, and help us better understand the past.

As with other aspects of the culture, renewal has also touched Roman cuisine. The wealth of ingredients and the centuries of experimentation have given rise to culinary standards such as pasta and rice dishes, and kitchen techniques basic to gastronomy all over the world. This priceless tradition is explored, but not transformed, from avant-garde perspectives, and new ingredients enhance the possibilities they offer. In the dishes the establishments serve and in their décor, modernity and tradition come together. Inspiration is not found in what is fashionable, but seeks to exalt the Roman spirit. Stores that sell Italian products become restaurants, cake shops offer lunch and dinner, famous sites decide to renovate, paint the walls a fresh color, and reposition the works of art, photographs, and newspaper clippings that covered them—another testament to antiquity, prestige, and Roman tradition.

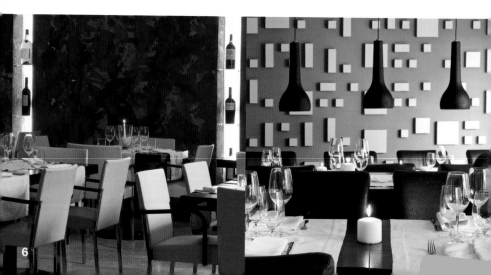

# Einleitung

Rom wird auch die ewige Stadt genannt und es scheint wirklich, als ob es sie schon immer gab. Ein Eindruck, der sich noch verstärkt, wenn man durch ihre Straßen läuft, wo man einer eindrucksvollen tausendjährigen Kunst- und Architekturgeschichte begegnet. Die Einwohner verehren ihre Stadt und sind sich ihrer kulturellen Bedeutung bewusst. Rom erzeugt eine ganz besondere Atmosphäre, die vielen Besuchern den Ausruf „Wie im Film!" entlockt.

Rom ist tatsächlich wie im Film, denn genau wie auf Zelluloid, ist sie farbenprächtig, exzessiv, hinreißend, verführerisch und versprüht einen gewisses theatralisches Flair. Vielleicht ist es die patrizische Selbstgewissheit der Bewohner einer universalen Stadt mit einem unermesslichen historischen Wert, die dazu führt, dass die Römer selbstsicher und gemächlich durch die Straßen spazieren, mit dem Bewusstsein, dass sie einer herausragenden klassischen Kultur entstammen.

Rom beziehungsweise Italien im Allgemeinen hat die Moderne nicht als Erneuerung oder Ersatz des Bestehenden verstanden, sondern als eine neue Form das Klassische hervorzuheben und Akzente zu setzen, indem sie zeitgenössische Kunst- und Kulturbegriffe einführt, die sich von der Vergangenheit abheben, diese neu bewerten und helfen, sie besser zu verstehen.

Genau wie andere Bereiche der Kultur, hat die Erneuerung auch die römische Küche beeinflusst. Die Vielfalt der Zutaten und das jahrhundertelange Experimentieren haben kulinarische Meilensteine wie Nudel- oder Reisgerichte sowie Kochtechniken hervorgebracht, welche die Grundlagen der internationalen Gastronomie bilden. Diese wertvolle Tradition ist bekannt, aber aus avantgardistischer Sicht noch unberührt und kann durch neue Zutaten eine Bereicherung erfahren. Moderne und Tradition begegnen sowohl bei den Speisen, als auch bei den Einrichtungen der Lokale. Das Design lässt sich nicht von den gängigen Trends inspirieren, sondern preist den römischen Geist. Italienische Spezialitätengeschäfte werden zu Restaurants, Konditoreien bieten Mittag- und Abendessen an, namhafte Lokale entscheiden sich zum Umbau, streichen die Wände in einer anderen Farbe und hängen Bilder, Fotografien und Zeitungsausschnitte in anderer Reihenfolge auf. Ein Beweis mehr für Reife, Prestige und römische Tradition.

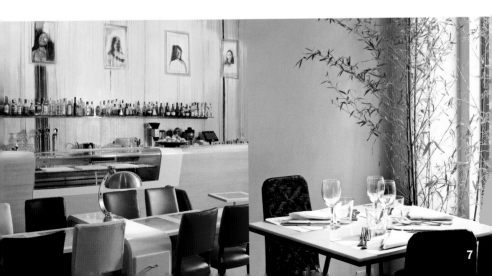

# Introduction

Rome reçoit également le titre de Cité Éternelle. Elle semble en effet avoir existé de tous temps. Une impression accentuée en parcourant ses rues où l'art et l'architecture millénaires viennent à notre rencontre de manière démesurée. Conscients de son importance culturelle, ses habitants vouent un culte à la cité et au fait d'être romain, créant une atmosphère si caractéristique arrachant à nombre de visiteurs un « comme dans les films ! » signe d'abandon.

Car Rome est bien comme dans les films. Comme sur la pellicule, elle s'affiche colorée et excessive, irrésistible et séductrice et dégage une certaine théâtralité, peut être pour l'ego quasi patricien de sa population, fière d'une cité qui se sait universelle et d'une valeur historique incommensurable : ses citoyens flânent, tranquilles et sûrs d'eux-mêmes, conscients du poids d'une culture classique hors du commun.

Rome (et l'Italie en général) n'a pas compris la modernité comme une rénovation ou une substitution de l'existant mais bien comme une nouvelle forme de souligner et accentuer le classique, introduisant des concepts d'art et de culture contemporains contrastant, revalorisant et aidant à mieux comprendre le passé. Comme d'autres aspects de la culture, la rénovation a également influencé la cuisine romaine. La richesse des matières premières et l'expérimentation au fil des siècles ont donné naissance à des succès culinaires, les pâtes ou le riz, et à des techniques de cuisine figurant parmi les piliers de la gastronomie universelle. Cette précieuse tradition est explorée, sans être transformée, avec des vues avant-gardistes et de nouveaux ingrédients s'ajoutent à ses possibilités. Les plats comme la décoration des établissements ont vu fusionner tradition et modernité : le design ne s'inspire pas de l'air du temps ou de la mode mais cherche plutôt à exalter l'esprit romain. Les magasins de produits italiens se convertissent en restaurants, les confiseries offrent déjeuners et dîners, des sites de renom décident de se rénover, repeignant leurs murs et réorganisant cadres, photographies et coupures de presse les tapissant : un nouveau témoignage de l'antiquité, du prestige et de la tradition romaines.

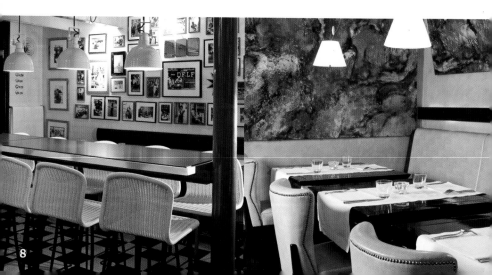

# Introducción

Roma recibe también el nombre de Ciudad Eterna, y es que parece que siempre ha estado ahí. Una impresión que se acentúa al recorrer sus calles, donde arte y arquitectura milenarias salen a nuestro encuentro en proporción impresionante. Conscientes de su importancia cultural, sus habitantes practican un culto a la ciudad y al hecho de ser romano que crea una atmósfera tan característica que arranca a muchos visitantes un entregado "¡cómo en las películas!".

Y es que Roma es como en las películas, porque, igual que en el celuloide, resulta colorista y excesiva, arrolladora y seductora, y desprende cierto aire teatral, quizá por el ego casi patricio de su población, orgullosa de una ciudad que sabe universal y de inconmensurable valor histórico; sus ciudadanos pasean tranquilos y seguros de sí mismos, conscientes de un saber hacer que es fruto de una tradición milenaria.

Roma (e Italia, en general) no ha entendido la modernidad como renovación o sustitución de lo existente, sino como una nueva forma de resaltar y acentuar lo clásico, introduciendo conceptos de arte y cultura contemporáneos que contrastan, revalorizan y ayudan a entender mejor el pasado.

Igual que a otros aspectos de la cultura, la renovación ha llegado también a la cocina romana. La riqueza en materias primas y la experimentación a lo largo de los siglos ha dado lugar a hitos culinarios como la pasta o los arroces y a técnicas de cocina que figuran entre los fundamentos de la gastronomía universal. Esta valiosa tradición es explorada, pero no transformada, desde puntos de vista vanguardistas, y nuevos ingredientes aumentan sus posibilidades. Tanto en los platos como en la decoración de los establecimientos, modernidad y tradición se funden; el diseño no se inspira en lo que se lleva o en la moda, sino que busca exaltar el espíritu romano. Tiendas de productos italianos se convierten en restaurantes, fábricas de dulces ofrecen comidas a mediodía y a la hora de la cena, locales de renombre deciden renovarse, pintan las paredes de otro color y vuelven a colocar, quizá en otro orden, los cuadros, las fotografías y los recortes de periódico que las cubrían, como un testimonio más de antigüedad, prestigio y tradición romana.

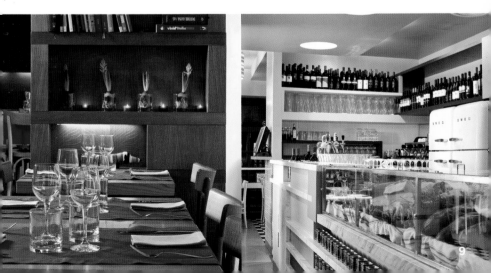

# Acqua Negra

Design: Ilaria Petreni | Chef: Giuseppe Fulgidezza

Largo del Teatro Valle 9 | 00186 Rome
Phone: +39 06 68136830
www.acquanegra.it
Opening hours: Mon–Sun noon to midnight
Average price: € 30
Cuisine: Creative Italian cuisine
Special features: Modern, minimalist design in a historic palace

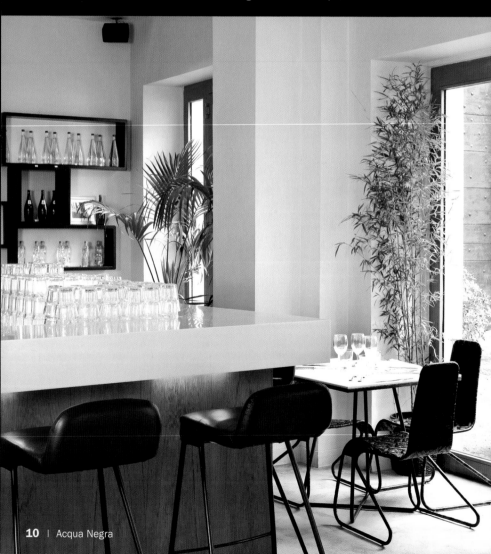

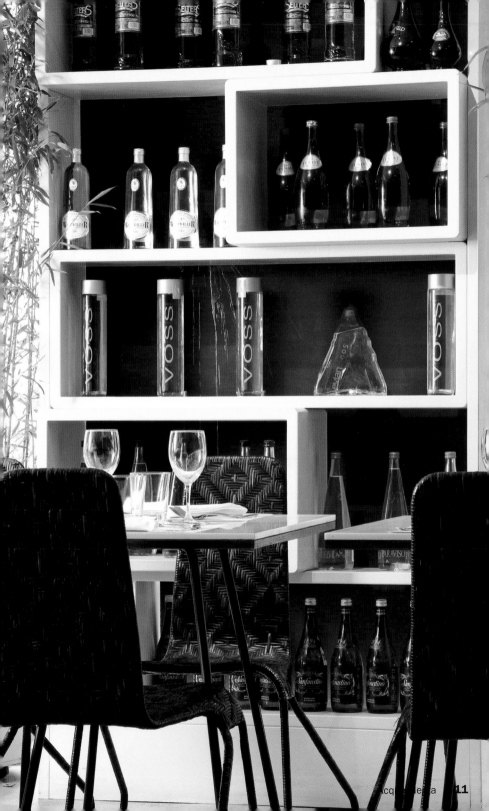

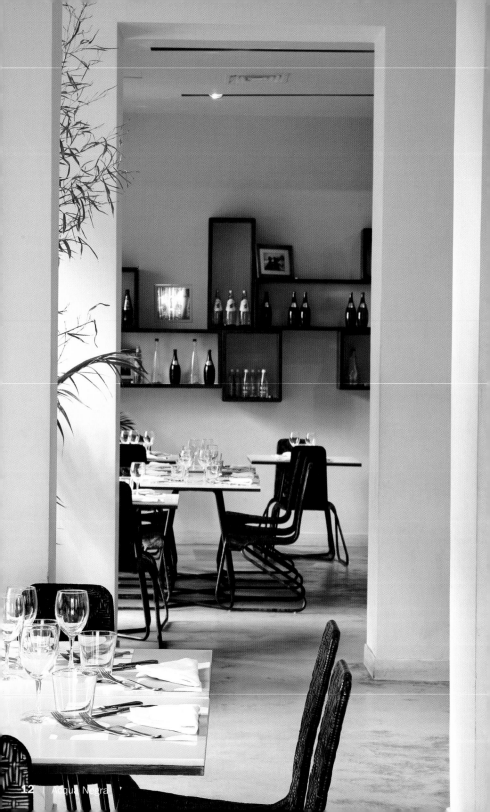

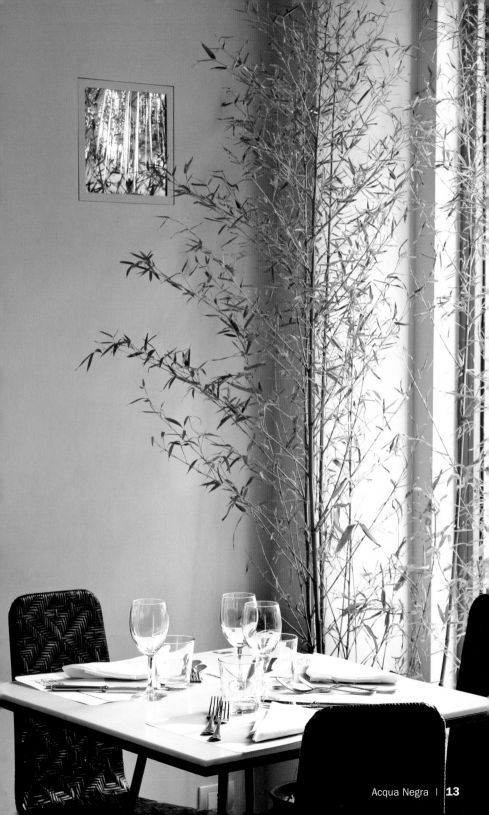

# Tonnarelli

Tonnarelli
Pasta tonnarello
Pâtes tonnarello
Pasta tonnarello

400 g di tonnarelli
100 g di Castelmagno grattugiato
2 cuori di radicchio di Treviso
1 gambo di sedano
1 carota
1 cipolla
100 g di pancetta
250 ml di vino rosso
200 ml di olio di oliva
Rosmarino
Basilico

In una casseruola con acqua, far bollire la pasta per 5 minuti fino a che non sia al dente. Scolare e mettere da parte. Tagliare la pancetta a dadi e soffriggerla in una padella con dell'olio. A metà cottura, aggiungere il sedano, la carota e la cipolla ben tritati e mettere a riposo. In un'altra padella versare il vino e il rosmarino e far ridurre. Dopodiché, aggiungere il liquido al preparato di verdure e mescolare per bene.
Presentazione: Disporre la pasta in un piatto e bagnarla con il composto di verdure. Aggiungere i cuori di radicchio tagliati a pezzi e spolverizzare con il formaggio. Decorare con un rametto di rosmarino e le foglie di basilico.

14 oz Tonnarelli
3 1/2 oz grated Castelmagno cheese
2 hearts Treviso radicchio
1 celery stalk
1 carrot
1 onion
3 1/2 oz bacon
250 ml red wine
200 ml olive oil
Rosemary
Basil leaves

In a pan, boil the pasta in water for 5 minutes until al dente. Drain and set aside. Cut the bacon into squares y fry in a skillet with oil. When it's half cooked, add the chopped celery, carrot, and onion. Set aside. Place the wine and rosemary in another skillet and reduce. When ready, add the vegetables and mix well.
Presentation: Place the pasta on a plate and top with the vegetable mixture. Add the chopped radicchio and sprinkle with cheese. Garnish with a sprig of rosemary and the basil leaves.

400 g Pasta tonnarello
100 g geriebenen Castelmagno Käse
2 Radicchio de Treviso Salatherzen
1 Selleriestange
1 Karotte
1 Zwiebel
100 g Speck
250 ml Rotwein
200 ml Olivenöl
Rosmarin
Basilikum

Die Nudeln in einem Topf 5 Minuten lang in Wasser kochen lassen bis sie ‚al dente' (bissfest) sind. Wasser abgießen und Nudeln beiseite stellen. Den Speck in Würfel schneiden und in einer Pfanne mit Öl anbraten. Kurz danach den klein geschnittenen Sellerie, die zerkleinerte Karotte sowie die fein gehackten Zwiebeln dazugeben und zur Seite stellen. Wein und Rosmarin in eine andere Pfanne geben und auf kleiner Flamme reduzieren lassen. Danach das Gemüse hinzugeben und gut miteinander vermischen.
Servieren: Die Nudeln auf einen Teller geben und die Gemüsemischung darüber verteilen. Die klein geschnittenen Radicchio-Salatherzen dazugeben und mit dem Käse bestreuen. Mit einem kleinen Zweig Rosmarin und den Basilikumblättern dekorieren.

400 g de pâtes tonnarello
100 g de fromage Castelmagno râpé
2 cœurs de chicorée de Trévise
1 branche de céleri
1 carotte
1 oignon
100 g de lard
250 ml de vin rouge
200 ml d'huile d'olive
Romarin
Basilic

Dans une casserole avec de l'eau, faire cuire les pâtes al dente, en 5 minutes. Égoutter et réserver. Couper le lard en dés et le faire revenir dans une poêle avec de l'huile. À mi-cuisson, ajouter le céleri, la carotte et l'oignon émincés et réserver. Dans une autre poêle, verser le vin, ajouter le romarin et laisser réduire. Une fois prêt, ajouter à la préparation de légumes et bien mélanger.
Présentation : Disposer les pâtes dans un plat et baigner du mélange de légumes. Ajouter les cœurs de chicorée détaillés et saupoudrer de fromage. Décorer d'un brin de romarin et des feuilles de basilic.

400 g de pasta tonnarello
100 g de queso Castelmagno rallado
2 cogollos de radicchio de Treviso
1 rama de apio
1 zanahoria
1 cebolla
100 g de tocino
250 ml de vino tinto
200 ml de aceite de oliva
Romero
Albahaca

En una cacerola con agua, hervir la pasta durante 5 minutos hasta que quede al dente. Colar y reservar. Cortar el tocino en dados y sofreírlo en una sartén con aceite. A media cocción, añadir el apio, la zanahoria y la cebolla picados y reservar. En otra sartén echar el vino y el romero y dejar reducir. Una vez listo, añadir al preparado de verduras y mezclar bien.
Emplatado: Disponer la pasta en un plato y bañar con la mezcla de verduras. Añadir los cogollos de radicchio picados y espolvorear con el queso. Decorar con una ramita de romero y las hojas de albahaca.

# Bloom

## Design: In house architects I Chef: Giovanni Scomazzon

Via del Teatro Pace 29–30 I 00186 Rome
Phone: +39 06 68802029 / +39 06 68301808
bloom@rome.com
Opening hours: Mon–Sat 8:30 pm to 4 am
Average price: € 55
Cuisine: Contemporary, classic, and sushi
Special features: Sessions with famous discjockeys starting at 12:30 am; Mondays
Bloommonday with special offers

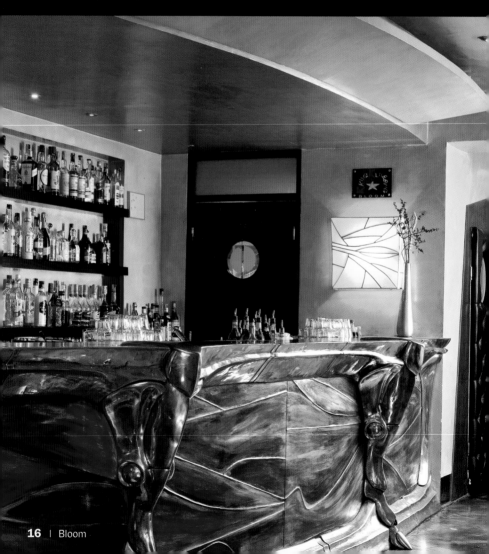

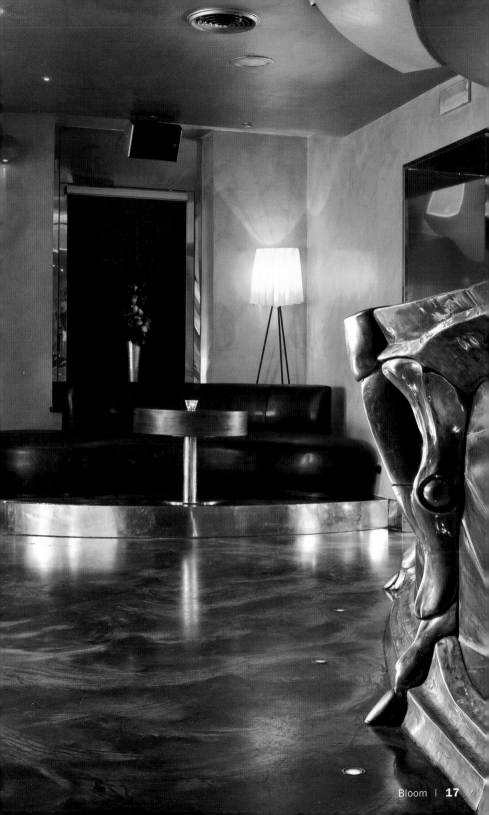

# Branzino

## al vapore

Steamed Sea Bass
Gedämpfter Wolfsbarsch
Bar à la vapeur
Lubina al vapor

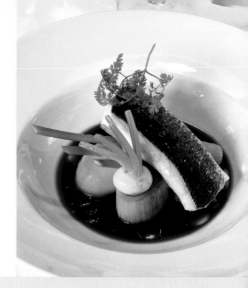

150 g di insalatina mista
200 g di branzino d'altura
30 ml di salsa di soia
30 ml di sake
Prezzemolo

Cuocere al vapore l'insalatina mista per 6 minuti. Nel frattempo, pulire il branzino, togliere le spine e sfilettarlo senza eliminare la pelle. Aggiungere i filetti al preparato di verdure e fare cuocere per altri 5 minuti. In un recipiente a parte, mescolare la soia e il sake.
Presentazione: Disporre le verdure nel fondo di un piatto, su di esse adagiarvi i filetti di branzino e cospargere abbondantemente di salsa di soia e sake. Decorare con i rametti di prezzemolo.

5 oz mixed baby vegetables
7 oz deep sea bass
30 ml soy sauce
30 ml sake
Parsley

Steam the baby vegetables for 6 minutes. Meanwhile, clean the sea bass, remove the bones, and fillet without removing the skin. Add the fillets to the vegetables and steam 5 minutes more. In a bowl, mix the soy sauce and sake.
Presentation: Arrange the vegetables on a plate, place the fillets of sea bass on top, and drizzle the soy and sake sauce liberally. Garnish with the parsley sprigs.

150 g junge Gemüsemischung
200 g Wolfsbarsch
30 ml Sojasoße
30 ml Sake (Reiswein)
Petersilie

Das Gemüse 6 Minuten lang im Dampf garen. Währenddessen den Wolfsbarsch putzen, entgräten und die Filetstücke herausschneiden ohne die Haut zu entfernen. Die Fischfilets in die Gemüsemischung legen und weitere 5 Minuten im Dampf garen. In einer weiteren Schüssel die Sojasoße und den Sake mischen. Servieren: Das Gemüse auf einem Teller verteilen, darüber die Wolfsbarschfilets legen und mit reichlich Sojasoße und Sake übergießen. Mit den Petersilienzweigen verzieren.

150 g de légumes baby mixtes
200 g de bar de haute mer
30 ml de sauce soja
30 ml de saké
Persil

Cuire les légumes à la vapeur durant 6 minutes. Pendant ce temps, laver le bar, enlever les arêtes et préparer des filets sans enlever la peau. Ajouter les filets aux légumes et terminer la cuisson durant 5 minutes additionnelles. Dans un récipient séparé, mélanger le soja et le saké. Présentation : Disposer les légumes au fond du plat, les couvrir avec les filets de bar et arroser abondamment avec la sauce de soja et de saké. Décorer avec les brins de persil.

150 g de verduras baby mixtas
200 g de lubina de altura
30 ml de salsa de soja
30 ml de sake
Perejil

Cocer al vapor las verduras baby durante 6 minutos. Mientras, limpiar la lubina, quitar las espinas y sacar los filetes sin eliminar la piel. Añadir los filetes al preparado de verduras y teminar de cocer durante 5 minutos más. En un recipiente aparte, mezclar la soja y el sake. Emplatado: Disponer las verduras en el fondo de un plato, colocar sobre ellas los filetes de lubina y rociar abundantemente con la salsa de soja y sake. Adornar con los ramilletes de perejil.

# Crudo

Design: Adriana Premeru I Chef: Alessandro Miotto

Via degli Specchi 6 I 00186 Rome
Phone: +39 06 6838989
www.crudoroma.it
Opening hours: Tue–Sat 12:30 pm to 3:30 pm, 9 pm to midnight, Monday closed for dinner and Sunday for lunch
Average price: € 30–35
Cuisine: Fish, meat, cheese, and vegetables
Special features: You can sample several uncooked dishes

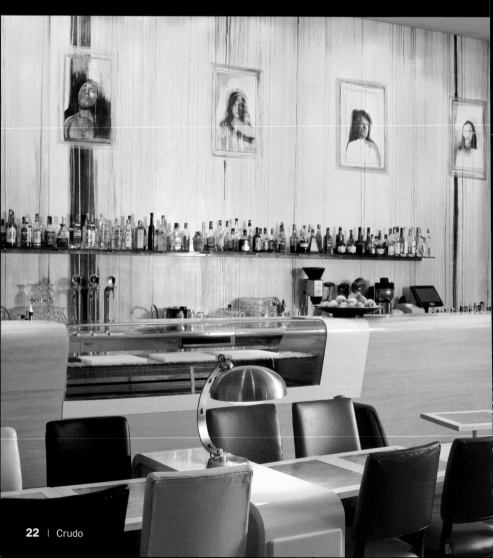

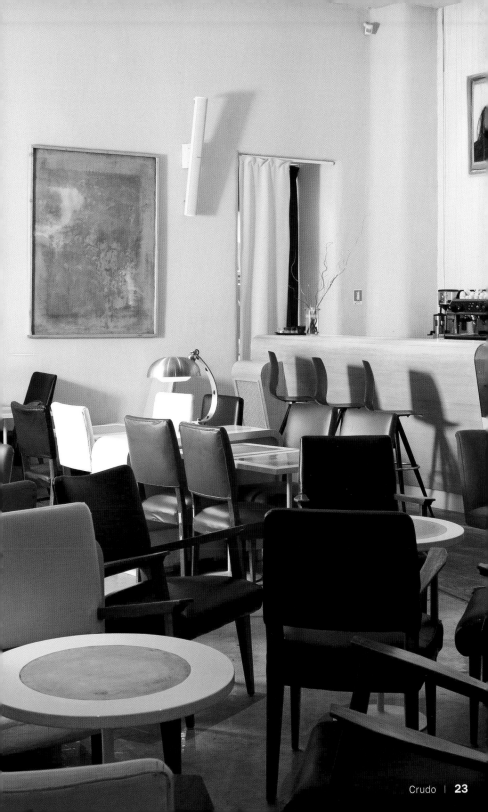

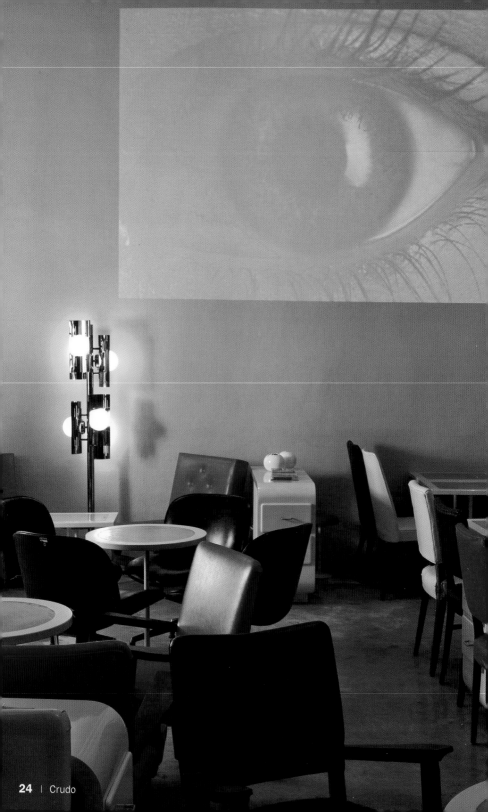

# Tonno

## con riso profumato

Tuna with Aromatic Rice
Thunfisch mit parfümiertem Reis
Thon au riz parfumé
Atún con arroz perfumado

120 g di tonno crudo a dadi
500 ml di latte di cocco
50 g di galanga
Scorza grattugiata di un limone
1 peperoncino piccante rosso
1 peperoncino piccante verde
1 cipolla
4 radici di coriandolo
50 g di riso thai
50 ml di succo di limetta
50 ml di salsa Tom Yam
2 foglie di erba cedrina
1 cetriolo
Prezzemolo

Cuocere il riso in 200 ml d'acqua. Scolare e mettere da parte. In una pentola bollire il latte di cocco. Mentre il latte bolle, tritare e aggiungere i seguenti ingredienti: la galanga, la scorza grattugiata di limone, i peperoncini, la cipolla e le radici di coriandolo. Ridurre il composto di un terzo. Ritirare dal fuoco e condire con il succo di limetta e con la salsa Tom Yam.
Presentazione: Versare e stendere in un piatto il contenuto della pentola. Al centro, sistemare i dadi di tonno e decorare con le foglie di erba cedrina e le foglie di prezzemolo. A parte, in un piatto più piccolo, servire il riso bianco ornato, se si desidera, con delle rondelle di cetriolo.

4 oz raw tuna, cut into squares
500 ml coconut milk
1 3/4 oz galangale
Grated rind of one lemon
1 red chili
1 green chili
1 onion
4 roots of cilantro
1 3/4 oz Thai rice
50 ml lime juice
50 ml Tom Yam sauce
2 stalks of lemon grass
1 cucumber
Parsley

Boil the rice in 200 ml water. Drain and set aside. Boil the coconut milk in a pan. Grind and add to the boiling milk: galangale, lemon rind, chilis, onion, and cilantro sprigs. Reduce the soup by a third. Remove from heat and sprinkle with lime juice and Tom Yam sauce.
Presentation: Turn the contents of the pan onto a plate and spread out. In the center, arrange the squares of tuna and garnish with the lemon grass and parsley leaves. On a separate, smaller plate, serve the white rice. If desired, garnish with cucumber slices.

120 g roher Thunfisch in Würfeln
500 ml Kokosmilch
50 g Galanga
Raspeln einer Zitronenschale
1 rote Chilischote
1 grüne Chilischote
1 Zwiebel
4 Korianderwurzeln
50 g thailändischer Reis
50 ml Limonensaft
50 ml Tom Yam Soße
2 Stängel Zitronengras
1 Gurke
Petersilie

Reis in 200 ml Wasser kochen, abtropfen lassen und beiseite stellen. Kokosmilch in einem Topf zum Kochen bringen. Folgende Zutaten zermahlen und in die kochende Milch hinzugeben: Galanga, Zitronenschale, Chilischoten, Zwiebel und Korianderwurzeln. Suppe um ein Drittel reduzieren, vom Herd nehmen und mit dem Limonensaft und der Tom Yam Soße würzen. Servieren: Den Inhalt des Topfes auf einen Teller gießen und verteilen. In die Mitte den gewürfelten Thunfisch legen und mit den Zitronengrasstängeln sowie der Petersilie verzieren. Auf einem kleineren Teller den weißen Reis servieren und nach Geschmack mit Gurkenscheiben drapieren.

120 g de thon cru en dés
500 ml de lait de coco
50 g de galanga
Un zeste de citron
1 chili rouge
1 chili vert
1 oignon
4 racines de coriandre
50 g de riz thaï
50 ml de jus de citron vert
50 ml de sauce Tom Yam
2 bâtonnets de citronnelle
1 coucombre
Persil

Cuire le riz dans 200 ml d'eau. Égoutter et réserver. Faire bouillir le lait de coco dans une casserole. Hacher et ajouter au lait à ébullition les ingrédients suivants : galanga, zeste de citron, chilis, oignon et racines de coriandre. Faire réduire la soupe d'un tiers. Retirer du feu et assaisonner avec le jus du citron vert et la sauce Tom Yam.
Présentation : Verser dans un plat le contenu de la casserole et l'étendre. En son centre, disposer les dés de thon et décorer des bâtonnets de citronnelle et des feuilles de persil. À part, dans un plat plus petit, servir le riz blanc en l'animant, selon les goûts, de rondelles de concombre.

120 g de atún crudo en dados
500 ml de leche de coco
50 g de galanga
Ralladura de un limón
1 chile rojo
1 chile verde
1 cebolla
4 raíces de cilantro
50 g de arroz thai
50 ml de zumo de lima
50 ml de salsa Tom Yam
2 barritas de hierba de limón
1 pepino
Perejil

Cocer el arroz en 200 ml de agua. Escurrir y reservar. Hervir en una cacerola la leche de coco. Triturar y añadir a la leche en ebullición los siguientes ingredientes: galanga, ralladura de limón, chiles, cebolla y raíces de cilantro. Reducir la sopa en un tercio. Retirar del fuego y aderezar con el zumo de lima y con la salsa Tom Yam.
Emplatado: Verter en un plato el contenido de la cacerola y extender. En el centro, disponer los dados de atún y adornar con las barritas de hierba limón y hojas de perejil. Aparte, en un plato más pequeño, servir el arroz blanco adornando, si se quiere, con rodajas de pepino.

# Dal Bolognese

Design: Ettore Tomaselli | Chef: Michele Zungoli

Piazza del Popolo 1–2 | 00187 Rome
Phone: +39 06 3611426
Subway: Flaminio
Opening hours: Tue–Sun 1 pm to 3:30 pm, 7:30 pm to midnight
Average price: € 40
Cuisine: Italian cuisine from the Emilia-Romagna region
Special features: In one of Rome's most important piazzas, heavily frequented
by tourists as well as prominent locals

# Tortellini ripieni

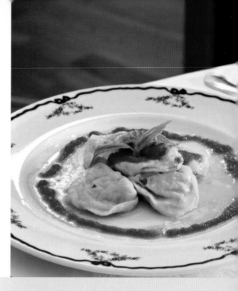

Stuffed Tortelli
Gefüllte Tortellini
Tortellinis farcis
Tortelli rellenos

100 g di farina
1 uovo
250 g di coda di bue
1 gambo di sedano
1 carota
1 cipolla
250 ml di vino bianco
100 ml di olio di oliva
50 g di burro
100 g di parmigiano grattugiato
50 ml di salsa di pomodoro fresco
Basilico
Sale

In un tegame con acqua far bollire la coda per 3 ore, disossarla e lasciarla raffreddare. Tritare il sedano, la carota e la cipolla e passare la coda al tritatutto. In una padella, riscaldare l'olio e soffriggere le verdure per 5 minuti. Aggiungere la coda tritata e far rosolare per altri 5 minuti. Prima di ritirare dal fuoco, spruzzare il tutto con del vino bianco. Su un tagliere, sistemare la farina a forma di monticello, fare un buco nel centro, aggiungervi l'uovo e impastare energicamente per 15 minuti. Stendere l'impasto con un matterello fino a formare un rettangolo sottile. Dopodiché ritagliare dei quadratini il cui lato sia di 3 cm e al centro di ognuno di essi sistemare un po' di ripieno. Piegare in due e unire i bordi. Riscaldare 500 ml di acqua, e una volta raggiunta l'ebollizione, aggiungere sale e i tortellini. Far cuocere per 5 minuti e scolare.
Presentazione: Versare i tortellini ancora caldi in un piatto, aggiungere il burro e mescolare fino a che non sia completamente sciolto. Spolverizzare con parmigiano e decorare con foglie di basilico e salsa di pomodoro fresco.

3 1/2 oz flour
1 egg
9 oz ox tail
1 celery stalk
1 carrot
1 onion
250 ml white wine
100 ml olive oil
1 3/4 oz butter
3 1/2 oz grated Parmesan cheese
50 ml fresh tomato sauce
Basil
Salt

In a pot, boil the ox tail in water for 3 hours, debone and allow to cool. Chop the celery, carrot, and onion and grind the tail. In a skillet, heat the oil and lightly fry the vegetables for 5 minutes. Add the ground tail and lightly fry 5 minutes more. Before removing from the heat, drizzle with white wine. On a board, place the flour in a mound, make a well in the center, add the egg, and knead vigorously for 15 minutes. With a rolling pin, roll out to a rounded rectangular shape. Cut into squares, 1 1/6 inch per side. Place a small amount of filling in the center of each square. Fold in two and seal the edges. Heat 500 ml water. When it boils, add salt and the tortellini. Cook for 5 minutes. Drain.
Presentation: Turn the warm tortellini onto a plate, add the butter and mix until the butter is completely melted. Sprinkle with Parmesan and garnish with basil leaves and fresh tomato sauce.

100 g Mehl
1 Ei
250 g Ochsenschwanz
1 Selleriestange
1 Karotte
1 Zwiebel
250 ml Weißwein
100 ml Olivenöl
50 g Butter
100 g geriebener Parmesan
50 ml frische Tomatensoße
Basilikum
Salz

Den Ochsenschwanz in einer Pfanne mit Wasser 3 Stunden lang kochen, das Ochsenschwanzfleisch vom Knochen lösen und abkühlen lassen. Sellerie, Karotte und Zwiebel waschen und in Stücke schneiden und den Ochsenschwanz durch den Fleischwolf drehen. Öl in einer Pfanne erhitzen und das Gemüse 5 Minuten lang dün-sten. Das zerkleinerte Fleisch hinzugeben und weitere 5 Minuten schmoren. Die Mischung mit Weißwein übergießen und vom Feuer nehmen. Das Mehl auf einem Brett zu einem Hügel formen, in der Mitte aushöhlen, das Ei hineingeben und 15 Minuten lang kräftig durchkneten. Den Teig mit einem Nudelholz hauchdünn zu einem Rechteck ausrollen. 3 cm kleine Quadrate herausschneiden, in deren Mitte etwas Füllung platzieren, zweimal zusammenfalten und die Enden miteinander verschließen. 500 ml Wasser zum Kochen bringen, Salz und die Tortellinis dazugeben, 5 Minuten kochen lassen und danach das Wasser abgießen.
Servieren: Die noch warmen Tortellini auf einem Teller verteilen, Butter hinzugeben und solange vermischen, bis die Butter vollständig zerlaufen ist. Parmesan darüber streuen, mit Basilikumblättern verzieren und mit der frischen Tomatensoße anrichten.

100 g de farine
1 œuf
250 g de queue de bœuf
1 branche de céleri
1 carotte
1 oignon
250 ml de vin blanc
100 ml d'huile d'olive
50 g de beurre
100 g de parmesan râpé
50 ml de sauce tomate fraîche
Basilic
Sel

Faire bouillir la queue dans une casserole d'eau pendant 3 heures. La désosser et la laisser refroidir. Hacher le céleri, la carotte et l'oignon et passer la queue au hachoir. Dans une poêle, faire chauffer l'huile pour y faire revenir les légu-mes pendant 5 minutes. Ajouter le hachis de queue et faire revenir 5 minutes de plus. Avant de retirer du feu, arroser de vin blanc. Sur une planche, disposer la farine en monticule, creuser un cratère en son centre, ajouter l'œuf et malaxer énergiquement durant 15 minutes. Étendre la pâte au rouleau pour former un rectangle assez fin. Découper en carrés de 3 cm de côté et, au centre de chacun, déposer un peu de farce. Plier en deux et joindre les bords. Faire chauffer 500 ml d'eau et, à ébullition, ajouter de la sel et les tortellinis. Laisser cuire 5 minutes. Égoutter.
Présentation : Verser les tortellinis encore chauds dans un plat. Ajouter le beurre et mélanger afin de le faire fondre entièrement. Saupoudrer de parmesan et décorer des feuilles de basilic et de sauce tomate fraîche.

100 g de harina
1 huevo
250 g de cola de buey
1 rama de apio
1 zanahoria
1 cebolla
250 ml de vino blanco
100 ml de aceite de oliva
50 g de mantequilla
100 g de queso parmesano rallado
50 ml de salsa de tomate fresca
Albahaca
Sal

En una cazuela con agua hervir la cola durante 3 horas, deshuesarla y dejarla enfriar. Picar el apio, la zanahoria y la cebolla y pasar la cola por la picadora. En una sartén, calentar el aceite y rehogar las verduras durante 5 minutos. Añadir la cola picada y rehogar durante 5 minutos más. Antes de retirar del fuego, rociar con vino blanco. Sobre una tabla, colocar la harina en forma de montículo, ahuecar el centro, añadir el huevo y amasar enérgicamente durante 15 minutos. Extender la masa con un rodillo hasta formar un rectángulo sutil. Recortar cuadraditos de 3 cm de lado y, en el centro de cada uno, colocar un poco de relleno. Plegar en dos y juntar los bordes. Calentar 500 ml de agua, cuando hierva, añadir sal y los tortellini. Dejar cocer durante 5 minutos. Escurrir.
Emplatado: Verter los tortellini aún calientes en un plato, añadir la mantequilla y mezclar hasta que esté completamente derretida. Espolvorear con parmesano y adornar con hojas de albahaca y salsa fresca de tomate.

# Deseo

Design: Cristiano Bonvini I Chef: Carlo Satta, Francisco Menéndez

Via di Priscilla 105–107 I 00199 Rome
Phone: +39 06 86391411
www.deseoroma.it
Opening hours: Mon–Fri 12:30 pm to 3 pm, Tue–Sat 7:30 pm to 12:30 am
Average price: € 40
Cuisine: Reinterpretation of traditional Italian cuisine, mixing elements from different regions
Special features: Offers an interesting avant-garde musical program all week

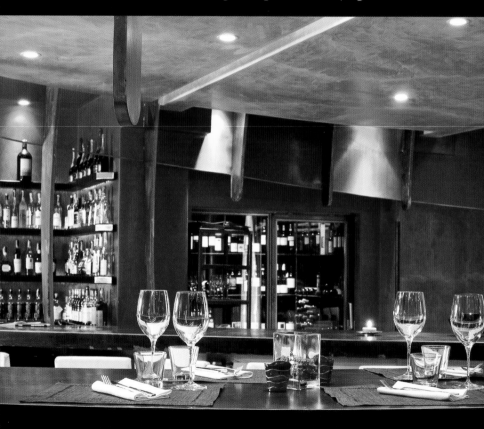

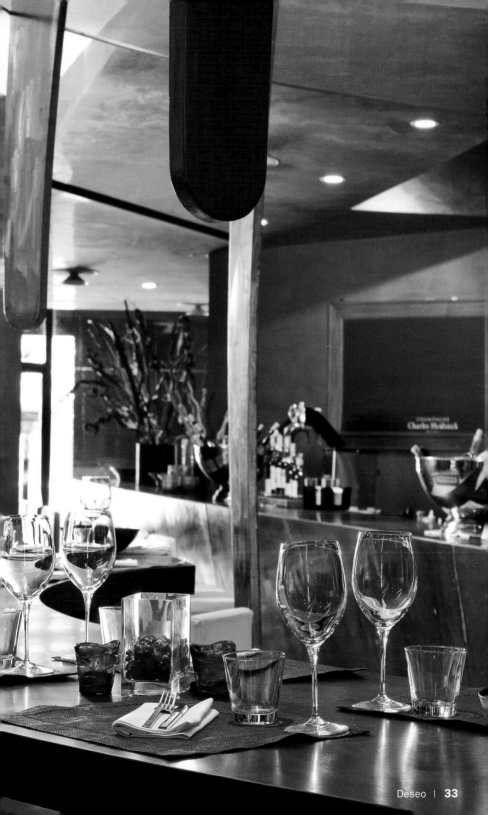

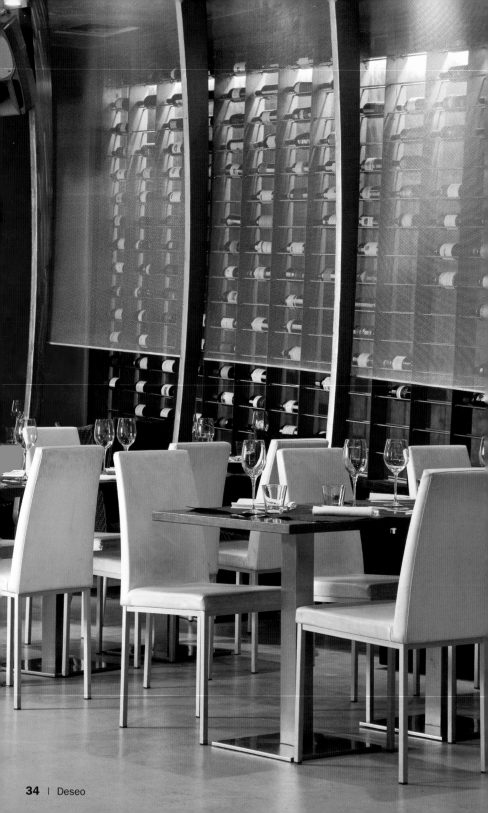

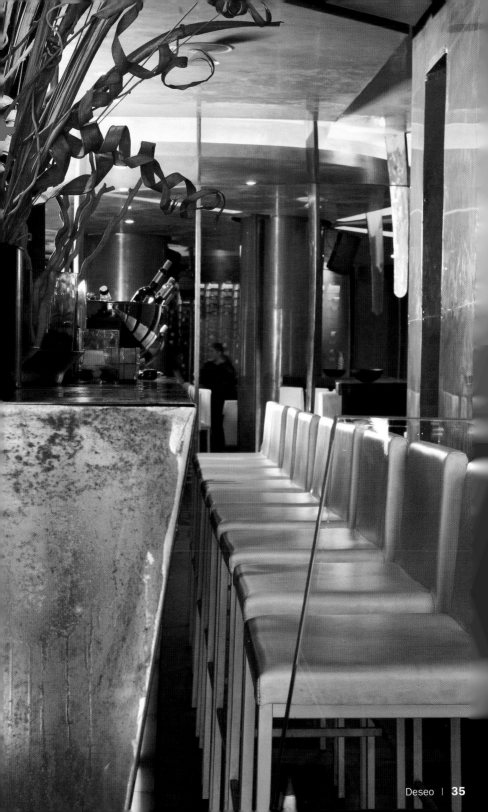

# Gamberetti

## con crema di ceci

Prawns with Chickpeas Cream
Riesengarnelen auf Kichererbsencreme
Langoustines avec de la crème de pois
chiches
Langostinos con crema de garbanzos

7 gamberetti
250 g di ceci secchi
1 l di brodo di frutti di mare
100 g di olio extra vergine di oliva
2 spicchi d'aglio
250 ml di vino bianco secco
1 fiore
Rosmarino

Versare il brodo di frutti di mare in una casse-
ruola, aggiungere il rosmarino, uno spicchio
d'aglio e i ceci. Far cuocere a fuoco medio per
1 ora e poi scolare. Passare i ceci al frullatore
fino ad ottenere una crema. In una padella, ri-
scaldare l'olio con uno spicchio d'aglio, intro-
durvi i gamberetti e saltarli per 1 minuto. Prima
di ritirare dal fuoco, cospargere di vino.
Presentazione: Collocare in un vassoio la crema
di ceci e su di essa adagiarvi i gamberetti a for-
ma di stella. Condire con olio e decorare con un
fiore.

7 prawns
9 oz dry chickpeas
1 l seafood stock
100 ml extra virgin olive oil
2 cloves garlic
250 ml dry white wine
1 flower
Rosemary

Pour the seafood stock into a casserole and add
the rosemary, one clove of garlic, and the chick-
peas. Cook 1 hour over medium heat. Drain.
Process the chickpeas in a blender until the con-
sistency of cream. In a skillet, heat the oil with
one clove of garlic, add the prawns, and sauté
for 1 minute. Before removing from the heat,
drizzle with wine.
Presentation: Place the chickpea paste on a
plate and arrange the prawns on top in a star
pattern. Dress with oil and garnish with a flower.

7 Garnelen
250 g getrocknete Kichererbsen
1 l Brühe aus Meeresfrüchten
100 ml Olivenöl Extra Vergine
2 Knoblauchzehen
250 ml trockener Weißwein
1 essbare Blüte
Rosmarin

Die Brühe aus Meeresfrüchten, den Rosmarin, eine Knoblauchzehe und die Kichererbsen in eine Kasserolle geben. Alles zusammen auf mittlerer Flamme 1 Stunde lang kochen und danach das Wasser abgießen. Die Kichererbsen in einem Mixer zu einer Creme pürieren. In einer Pfanne das Olivenöl erwärmen, die andere Knoblauchzehe hinzufügen, die Garnelen dazugeben und 1 Minute lang sautieren. Abschließend mit etwas Wein begießen.
Servieren: Die Creme aus Kichererbsen auf einer Servierplatte verteilen und die Garnelen sternförmig darüber anordnen. Mit etwas Öl umgießen und der Blüte verzieren.

7 langoustines
250 g de pois chiches secs
1 l de bouillon de crustacés
100 g d'huile d'olive vierge extra
2 pointes d'ail
250 ml de vin blanc sec
1 fleur
Romarin

Verser le bouillon de crustacés dans une casserole, ajouter le romarin, une pointe d'ail et les pois chiches. Cuire à feu moyen durant 1 heure. Égoutter. Passer les pois chiches au mixeur pour obtenir une crème. Dans une poêle, faire chauffer l'huile avec l'autre pointe d'ail, ajouter les langoustines et les faire sauter durant 1 minute. Avant de retirer du feu, arroser avec le vin.
Présentation : Verser la crème de pois chiches dans un plat creux et la couvrir des langoustines en formant une étoile. Assaisonner avec l'huile et décorer avec la fleur.

7 langostinos
250 g de garbanzos secos
1 l de caldo de marisco
100 g de aceite de oliva virgen extra
2 dientes de ajo
250 ml de vino blanco seco
1 flor
Romero

Verter el caldo de marisco en una cazuela, añadir el romero, un diente de ajo y los garbanzos. Cocer a fuego medio durante 1 hora. Escurrir. Pasar los garbanzos por la licuadora hasta obtener una crema. En una sartén, calentar el aceite con un diente de ajo, echar los langostinos y saltearlos durante 1 minuto. Antes de retirar del fuego, rociar con el vino.
Emplatado: Colocar en una fuente la crema de garbanzos y disponer los langostinos sobre la crema en forma de estrella. Aliñar con aceite y decorar con una flor.

# Fabrica

Design: Alessandro Di Calisto I Chef: Gianluca Di Calisto, Rita Spizzichini

Via Girolamo Savonarola 8 I 00195 Rome
Phone: +39 06 39725514
Subway: Ottaviano
Opening hours: Tue–Sun 7 pm to midnight
Average price: € 25
Cuisine: Avant-garde Italian
Special features: This is a cake shop opened in 1923 to which a café, tea room, wine bar, and restaurant have been added

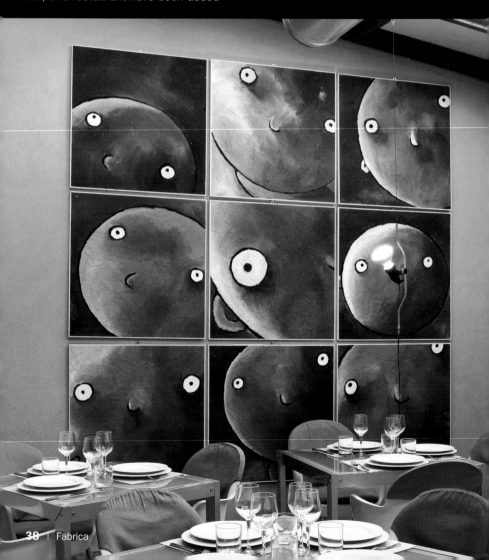

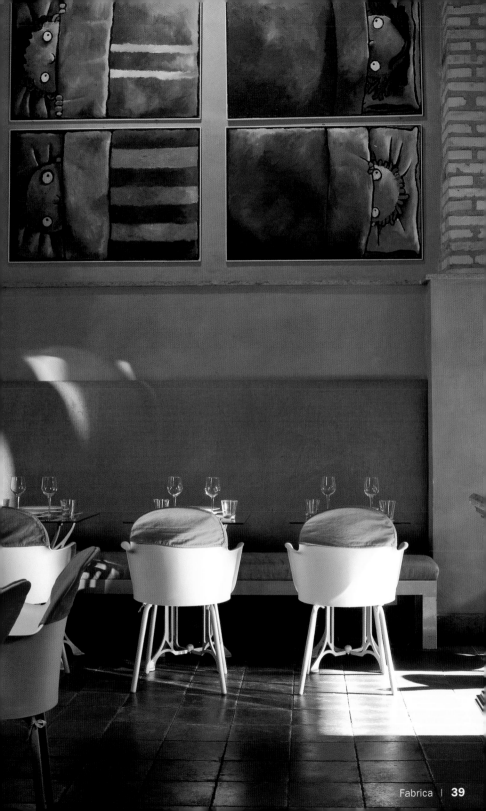

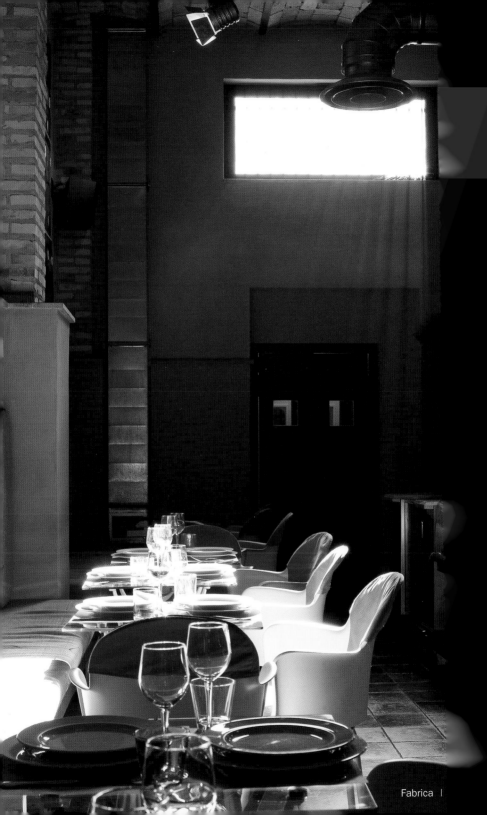

# Pasticcio
## di radicchio

Radicchio Cake
Radicchiokuchen
Gâteau de chicorée de Trévise
Pastel de radicchio

1 radicchio
50 g di burro
50 g di farina
500 ml di latte
3 zucchine
1 cipolla
1 spicchio d'aglio
50 g di semi di sesamo
150 ml di olio di oliva
200 g di orzo perlato
100 g di pangrattato
100 g di prosciutto cotto a fette sottili

Lavare il radicchio, asciugarlo e saltarlo in una padella con olio e uno spicchio d'aglio. Per preparare la besciamella, sciogliere il burro in un pentolino, aggiungervi la farina e il latte e far cuocere il preparato fino ad ebollizione. Cuocere l'orzo in acqua salata e in una padella saltare la cipolla e le zucchine tagliate a rondelle. Imburrare una tartiera e spolverizzare con pangrattato. Comporre il pasticcio alternando uno strato di besciamella, uno di radicchio e uno di prosciutto cotto. Finire il tutto con uno strato di besciamella, coprire con pangrattato e infornare per 40 minuti. Mescolare l'orzo con le zucchine e la cipolla, saltare i semi di sesamo e aggiungerli al preparato.
Presentazione: Servire ogni porzione di pasticcio con l'insalata d'orzo. Spolverizzare con i semi di sesamo tostati.

1 radicchio
1 3/4 oz butter
1 3/4 oz flour
500 ml milk
3 zucchini
1 onion
1 clove of garlic
1 3/4 oz sesame seeds
150 ml olive oil
7 oz pearl barley
3 1/2 oz bread crumbs
3 1/2 oz thinly-sliced cooked ham

Wash the radicchio, dry, and sauté in a skillet with oil and a clove of garlic. To prepare the bechamel sauce, melt the butter in a casserole, add the flour and milk, and cook until boiling. Cook the barley in salted water and sauté the onion and the sliced zucchini in a skillet. Grease a cake tin with butter and dust with bread crumbs. Build the cake by alternating layers of bechamel sauce, radicchio, and cooked ham, ending with a layer of bechamel sauce. Cover with bread crumbs and bake 40 minutes. Mix the barley with the zucchini and onion. Sauté the sesame seeds and add them to the mixture.
Presentation: Serve each portion of cake with the barley salad. Sprinkle with the toasted sesame seeds.

1 Radicchio
50 g Butter
50 g Mehl
500 ml Milch
3 Zucchini
1 Zwiebel
1 Knoblauchzehe
50 g Sesamsamen
150 ml Olivenöl
200 g Gerste
100 g Semmelbrösel
100 g gekochter Schinken in dünnen Scheiben

Den Radicchio waschen, trocknen und in einer Pfanne mit Öl und der Knoblauchzehe sautieren. Um die Béchamelsoße zuzubereiten, die Butter in einer Kasserolle auslassen, Mehl und Milch hinzugeben und die Mischung zum Kochen bringen. Die Gerste in Salzwasser kochen und die Zwiebel gemeinsam mit kleinen Zucchinischeiben in einer Pfanne sautieren. Eine Kuchenform mit Butter einfetten und die Semmelbrösel darin zerstreuen. Der Kuchen entsteht durch das Aufschichten der Béchamelsoße, dem Radicchio und dem gekochten Schinken. Zuletzt sollte der Kuchen mit einer Schicht Béchamelsoße bedeckt und Semmelbröseln bestreut werden. Danach 40 Minuten backen. Die Gerste mit Zucchini und Zwiebel vermengen, die Sesamsamen sautieren und zu der Mischung hinzufügen.
Servieren: Zu jedem Stück Kuchen etwas Gerstensalat servieren. Darüber geröstete Sesamsamen streuen.

1 chicorée de Trévise
50 g de beurre
50 g de farine
500 ml de lait
3 courgettes
1 oignon
1 pointe d'ail
50 g de graines de sésame
150 ml d'huile d'olive
200 g d'orge perlé
100 g de chapelure
100 g de jambon cuit en fines tranches

Laver la chicorée, la sécher et la faire sauter à la poêle avec de l'huile et une pointe d'ail. Pour préparer la béchamel, faire fondre le beurre dans une casserole puis ajouter la farine et le lait et laisser cuire la préparation jusqu'à ébullition. Cuire l'orge dans de l'eau salée et faire sauter à la poêle l'oignon avec les courgettes coupées en tranches. Beurrer un moule à gâteau et le saupoudrer de chapelure. Composer le gâteau en faisant alterner une couche de béchamel, une de chicorée et une jambon cuit. Terminer par une couche de béchamel, ouvrir de chapelure et passer au four durant 40 minutes. Mélanger l'orge avec la courgette et l'oignon. Faire sauter les graines de sésame et les ajouter à la préparation.
Présentation : Servir chaque portion du gâteau avec la salade d'orge. Saupoudrer des graines de sésame grillées.

1 radicchio
50 g de mantequilla
50 g de harina
500 ml de leche
3 calabacines
1 cebolla
1 diente de ajo
50 g de semillas de sésamo
150 ml de aceite de oliva
200 g de cebada perlada
100 g de pan rallado
100 g de jamón cocido en lonchas finas

Lavar el radicchio, secarlo y saltearlo en una sartén con aceite y un diente de ajo. Para preparar la besamel, derretir en una cazuela la mantequilla, añadir la harina y la leche y cocer el preparado hasta que hierva. Cocer la cebada en agua salada y saltear en una sartén la cebolla y los calabacines cortados en rodajas. Untar una tartera con mantequilla y espolvorear con pan rallado. Componer el pastel alternando una capa de besamel, una de radicchio y una de jamón cocido. Terminar con una capa de besamel, cubrir con pan rallado y hornear durante 40 minutos. Mezclar la cebada con el calabacín y la cebolla, saltear las semillas de sésamo y añadirlas al preparado.
Emplatado: Servir cada porción de pastel con la ensalada de cebada. Espolvorear con las semillas de sésamo tostadas.

# F.I.S.H. Fine International Seafood House

Design: Todisco & Bassi I Chef: Lincoln Amano

Via dei Serpenti 16 I 00184 Rome
Phone: +39 06 47824962
www.f-i-s-h.it
Subway: Cavour, Colosseo
Opening hours: Tue–Sun 1 pm to 4 pm, 7 pm to midnight
Average price: € 35
Cuisine: International fish specialties, sushi

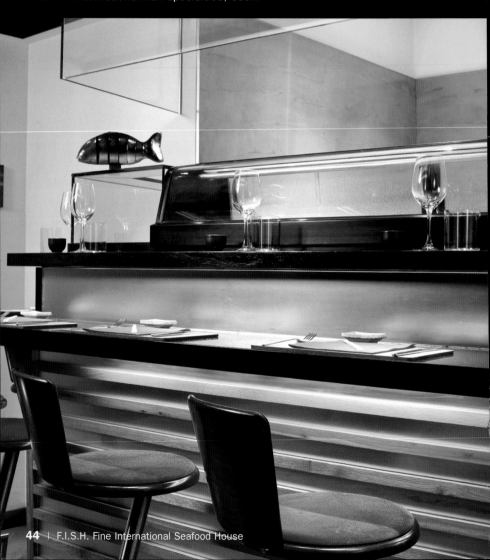

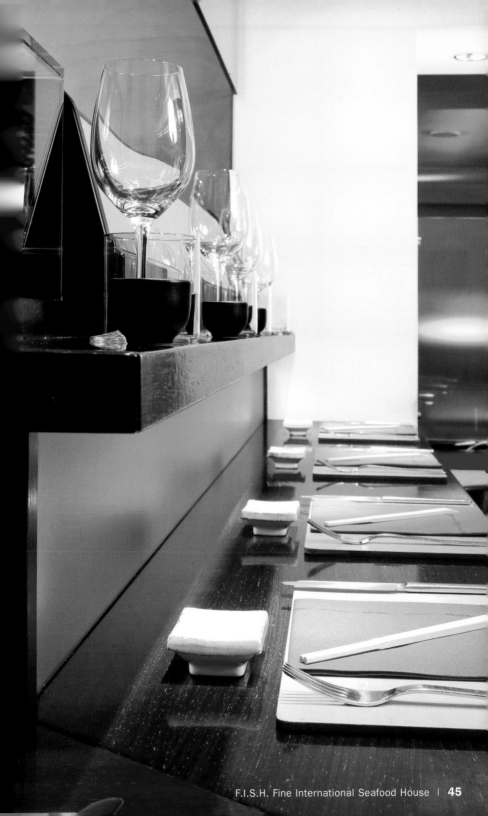

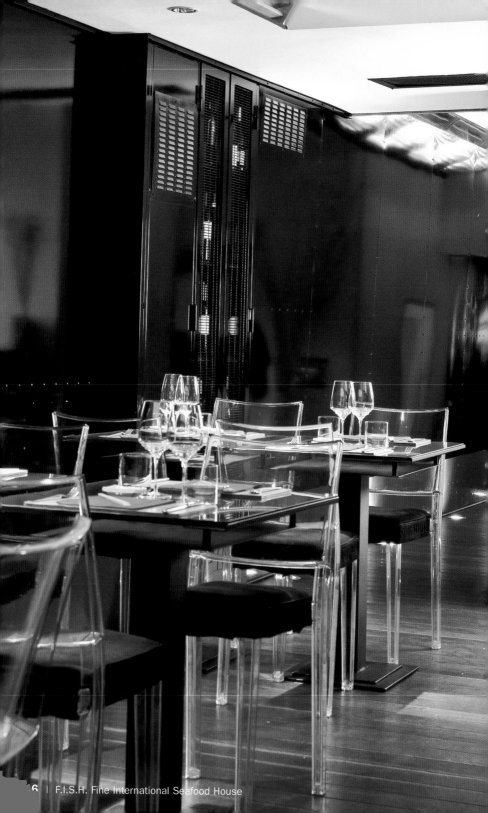

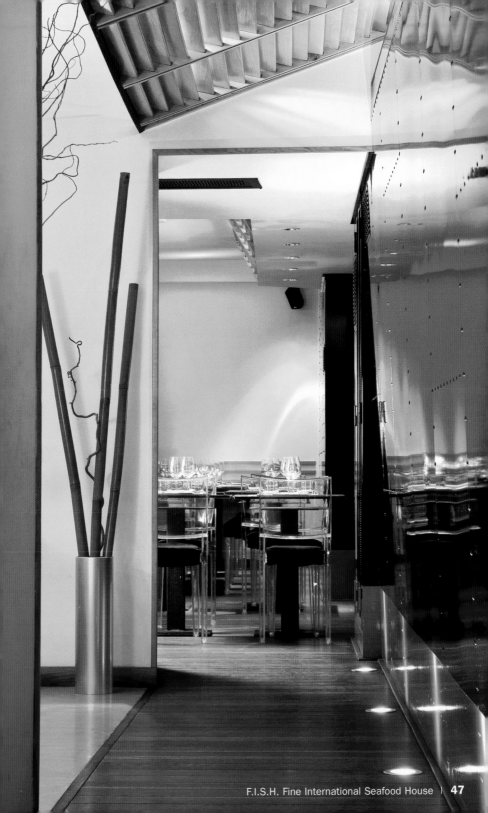

# Ceviche peruviano

Peruvian Ceviche

Peruanisches Ceviche

Ceviche péruvien

Ceviche peruano

150 g di leccia a dadi
3 spicchi d'aglio triturati
10 g di zenzero tritato
10 g di coriandolo
1 peperoncino piccante rosso
1 peperoncino piccante verde
1 cipolla rossa
1 limetta
1 foglia di lattuga cappuccina
1 gambero rosso crudo
1 rametto di mentuccia

Tagliare la leccia a dadi, aggiungere l'aglio e lo zenzero finemente tritati e salare. Tagliare i peperoncini a rondelle e unirli alla leccia assieme al coriandolo tritato. Sul preparato spruzzare il succo di limetta previamente spremuta, mescolare bene e lasciare riposare per 5 minuti.
Presentazione: Al centro di un piatto di portata, disporre i dadi di leccia sistemandoli sulla foglia di lattuga. Coronare il tutto con la cipolla tagliata a rondelle e decorare con il gambero crudo, una rondella di limetta e un rametto di mentuccia.

5 1/4 oz yellowtail cut into squares
3 cloves of garlic, crushed
1/3 oz ginger, chopped
1/3 oz cilantro
1 red chili
1 green chili
1 red onion
1 lime
1 leaf limestone lettuce
1 uncooked red shrimp
1 sprig of mint

Cut the serviola into squares, add the finely chopped garlic and ginger, and salt. Slice the chilis and add them to the serviola along with the chopped cilantro. Drizzle with lime juice, mix well, and let stand for 5 minutes.
Presentation: Arrange the squares of serviola on the lettuce leaf in the center of a plate. Top with sliced onion and garnish with the uncooked shrimp, a slice of lime, and a sprig of mint.

150 g gewürfelter Gelbschwanz
3 gehackte Knoblauchzehen
10 g kleingehackter Ingwer
10 g Korianderblätter
1 rote Chilischote
1 grüne Chilischote
1 rote Zwiebel
1 Limette
1 Blatt Kapuzinerkresse
1 rote rohe Garnele
1 Minzzweig

Den Gelbschwanz in Würfel schneiden, Knoblauch und Ingwer kleinhacken und anschließend salzen. Die Chilischoten in Scheiben schneiden und den Gelbschwanz mit dem gehackten Koriander beifügen. Diese Mischung mit dem Saft einer ausgepressten Limette begießen, gut vermischen und 5 Minuten ruhen lassen.
Servieren: In einer flachen Schale die Gelbschwanz-Würfel auf der Kapuzinerkresse drapieren. Den Gelbschwanz mit kleinen Zwiebelscheiben krönen und der rohen Garnele verzieren. Abschließend mit einer Limettenscheibe und einem Minzzweig dekorieren.

150 g de sériole en dés
3 pointes d'ail écrasé
10 g de gingembre haché
10 g de coriandre
1 chili rouge
1 chili vert
1 oignon rouge
1 citron vert
1 feuille de laitue capucine
1 crevette rouge crue
1 branche de menthe

Couper les sérioles en dés, ajouter l'ail et le gingembre finement hachés et saler. Couper les chilis en rondelles et les ajouter aux dés de sériole avec la coriandre hachée. Arroser le tout du jus de citron vert auparavant pressé, bien mélanger et laisser reposer 5 minutes.
Présentation : Disposer au centre d'un plat les dés de sériole sur une feuille de laitue. Couronner de l'oignon coupé en rondelles et décorer de la crevette crue, d'une tranche de citron vert et d'une branche de menthe

150 g de serviola en dados
3 dientes de ajo triturados
10 g de jengibre picado
10 g de cilantro
1 chile rojo
1 chile verde
1 cebolla roja
1 lima
1 hoja de lechuga capuchina
1 gamba roja cruda
1 ramita de hierbabuena

Cortar la serviola en dados, añadir el ajo y el jengibre finamente picados y salar. Cortar los chiles en rodajas y agregarlos a la serviola junto con el cilantro picado. Rociar el preparado con el zumo de la lima previamente exprimida, mezclar bien y dejar reposar durante 5 minutos.
Emplatado: Disponer en el centro de una fuente los dados de serviola sobre la hoja de lechuga. Coronar con la cebolla cortada en rodajas y adornar con la gamba cruda, una rodaja de lima y una ramita de hierbabuena.

# Gina

Design: Pierluigi Iommi I Chef: Eddy Medina

Via San Sebastianello 7A I 00187 Rome
Phone: +39 06 6780251
www.ginaroma.com
Subway: Spagna
Opening hours: Mon–Thu 11 am to 9 pm, Fri–Sun 11 am to midnight
Average price: € 20–25
Cuisine: Quality, quick and easy Mediterranean cuisine
Special features: Open all week, they prepare a picnic basket that can be enjoyed in nearby Villa Borghese park

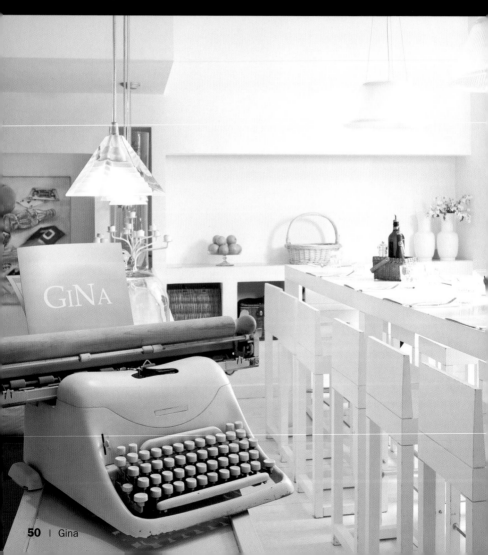

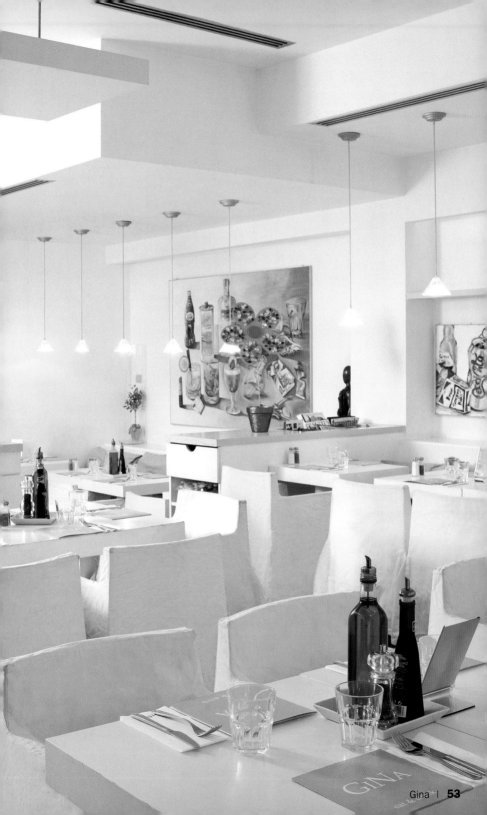

# Zuppa di farro

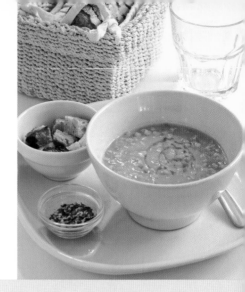

Spelt Soup
Dinkelsuppe
Soupe d'épeautre
Sopa de espelta

300 g di farro
150 ml di olio extra vergine di oliva
3 spicchi d'aglio
1 cipolla
1 carota
100 ml di vino bianco
200 g di pane casereccio
3 peperoncini rossi

Lasciare il farro a mollo per 12 ore. In una padella con olio di oliva, soffriggere l'aglio, la cipolla e la carota finemente tagliati. Unire il farro al soffritto e far cuocere per 40 minuti, aggiungendovi dell'acqua affinché il preparato non si asciughi. Tagliare il pane a fette, dopodiché tostarle e tagliarle a quadrati. Su un tagliere, tritare finemente i peperoncini.
Presentazione: Servire la zuppa in una scodella e accompagnarla con il pane tostato e il peperoncino tritato posti in due recipienti a parte. Condire la zuppa con olio di oliva crudo.

10 1/2 oz spelt
150 ml extra virgin olive oil
3 cloves of garlic
1 onion
1 carrot
100 ml white wine
7 oz homemade bread
3 red chilis

Soak the spelt for 12 hours. In a skillet, sauté the finely-chopped garlic, onion, and carrot in olive oil. Add the spelt to the vegetables and cook for 40 minutes, being careful to add water to keep the mixture from drying out. Slice the bread, toast, and cut into squares. On a board, finely chop the chilis.
Presentation: Serve the soup in a bowl, with the croutons and chopped chili in separate dishes. Drizzle the soup with crude olive oil.

300 g Dinkel
150 ml Olivenöl Extra Vergine
3 Knoblauchzehen
1 Zwiebel
1 Karotte
100 ml Weißwein
200 g hausgemachtes Brot
3 rote Chilischoten

Dinkel 12 Stunden lang in Wasser einweichen lassen. Knoblauch, Zwiebel und Karotte sehr klein schneiden und in einer Pfanne mit Olivenöl anbraten. Dinkel hinzufügen, 40 Minuten lang kochen lassen und gegebenenfalls Wasser hinzugeben, damit die Mischung nicht austrocknet. Das Brot in Scheiben schneiden, toasten und in Würfel schneiden. Die Chilischoten auf einem Küchenbrett in kleine Stückchen schneiden. Servieren: Die Suppe in einer Schüssel servieren und das geröstete Brot und die kleingeschnittenen Chilis in zwei weiteren Schalen dazureichen. Die Suppe mit Olivenöl verfeinern.

300 g d'épeautre
150 ml d'huile d'olive vierge extra
3 pointes d'ail
1 oignon
1 carotte
100 ml de vin blanc
200 g de pain maison
3 chilis rouges

Laisser tremper l'épeautre pendant 12 heures. Dans une poêle avec de l'huile d'olive, faire revenir l'ail, l'oignon et la carotte finement émincés. Ajouter l'épeautre et laisser cuire 40 minutes en prenant soin d'ajouter de l'eau afin que la préparation ne sèche pas. Couper le pain en tranches, les faire griller et les couper en carrés. Sur une planche, hacher finement les chilis. Présentation : Servir la soupe dans un plat creux et l'accompagner du pain grillé et du chili haché, dans deux plats séparés. Assaisonner la soupe avec l'huile d'olive crue.

300 g de espelta
150 ml de aceite de oliva virgen extra
3 dientes de ajo
1 cebolla
1 zanahoria
100 ml de vino blanco
200 g de pan casero
3 guindillas

Dejar la espelta en remojo durante 12 horas. En una sartén con aceite de oliva, sofreír el ajo, la cebolla y la zanahoria cortados finamente. Agregar la espelta al sofrito y dejar cocer durante 40 minutos cuidando de añadir agua para que el preparado no se seque. Rebanar el pan, tostarlo y cortarlo en cuadrados. En una tabla, picar finamente las guindillas. Emplatado: Servir la sopa en un cuenco y acompañarla con el pan tostado y la guindilla picada en dos recipientes aparte. Aliñar la sopa con aceite de oliva crudo.

# Gusto

### Design: Studioliorni | Chef: Marco Gallota

Piazza Augusto Imperatore 9 | 00100 Rome
Phone: +39 06 3226273
www.gusto.it
Subway: Spagna
Opening hours: Mon–Sun 12:30 pm to 3 pm, 7:30 pm to midnight
Average price: € 30
Cuisine: Creative Mediterranean cuisine
Special features: Large space with different areas and music every night

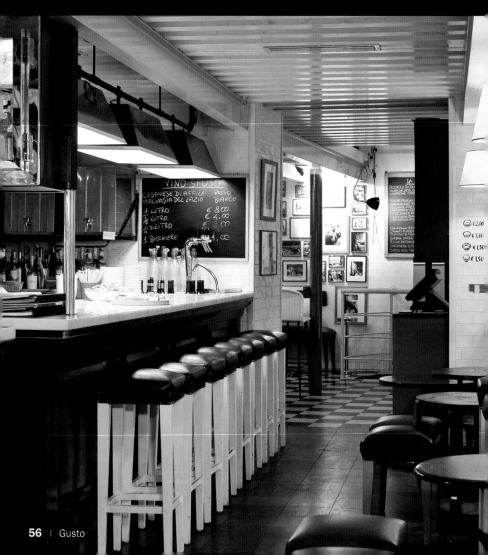

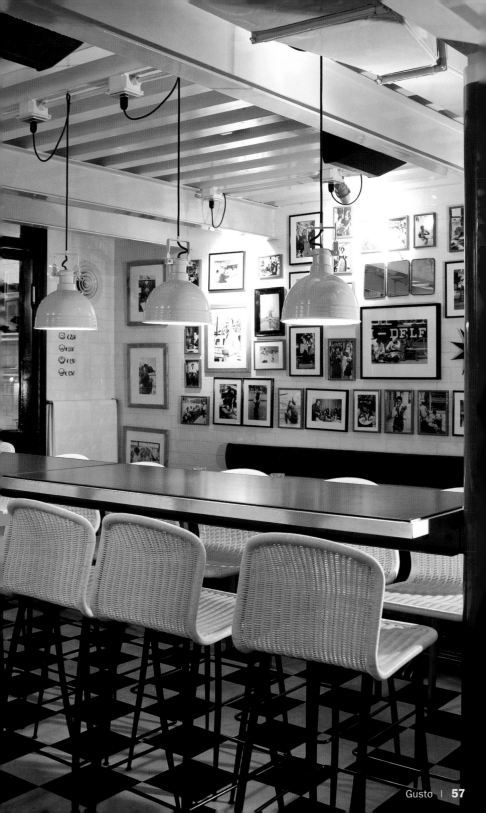

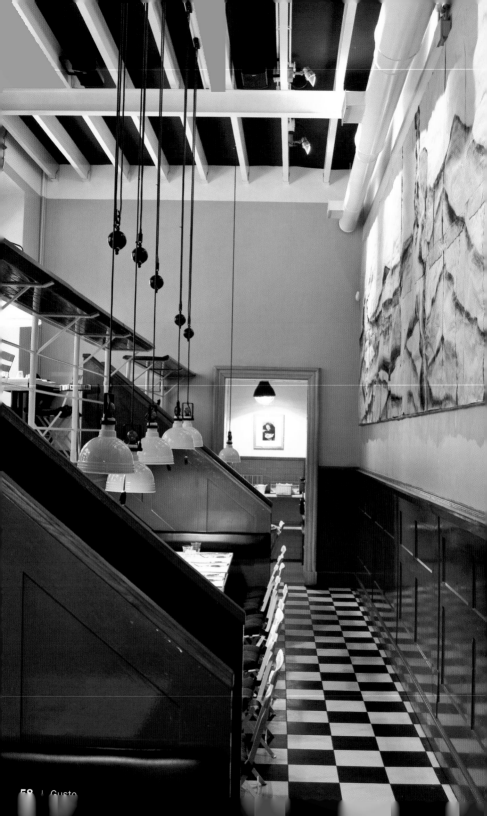

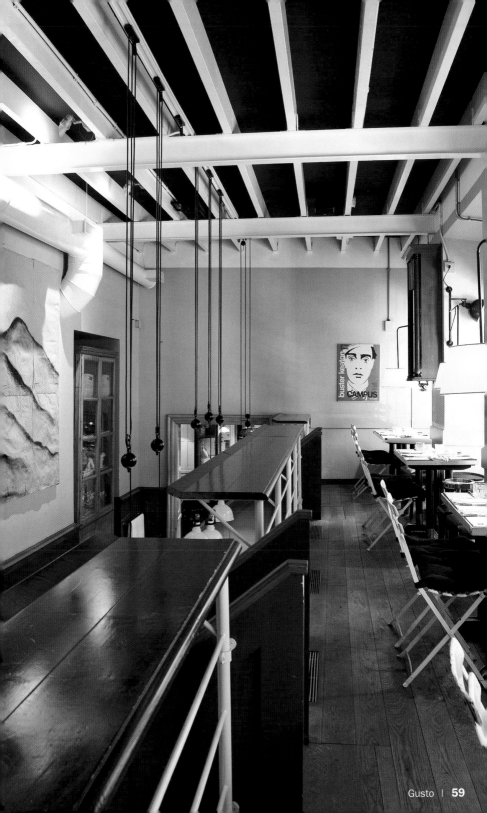

# Agnello al forno

Roast Lamb
Lammbraten
Agneau au four
Cordero al horno

1 cosciotto di agnello
1 carota
1 gambo di sedano
2 spicchi d'aglio
2 rametti di rosmarino
3 patate
150 ml di olio extra vergine di oliva
150 ml di vino bianco

In una teglia da forno unta con un po' di olio di oliva disporre le carote e il sedano tagliati a julienne. Cospargere il cosciotto di agnello di aglio e rosmarino e disporlo sul letto di verdure. Condire con sale e pepe. Spruzzarvi ancora un po' di olio e mettere in forno a 180 °C. Dopo 10 minuti, cospargere di vino bianco. Continuare la cottura per altri 30 minuti, dopodiché aggiungervi le patate pelate e tagliate a cubetti. Cuocere al forno per ancora 20 minuti.
Presentazione: Servire il cosciotto intero e coronarlo con una carota e del sedano freschi e un rametto di rosmarino. In ultimo, versate un filo d'olio crudo.

1 leg of lamb
1 carrot
1 celery stalk
2 cloves of garlic
2 sprigs of rosemary
3 potatoes
150 ml extra virgin olive oil
150 ml white wine

Place julienne-cut carrots and celery in an ovenproof dish with the olive oil. Season the leg of lamb with garlic and rosemary and place on the bed of vegetables. Add salt, pepper, garlic, and rosemary. Drizzle with oil and bake at 350 °F. After 10 minutes, drizzle with white wine. Cook for 30 minutes more, then add the potatoes, peeled and cubed. Bake 20 minutes more.
Presentation: Serve whole and top with fresh carrots and celery and a sprig of rosemary. Drizzle crude oil over all.

1 Lammhaxe
1 Karotte
1 Selleriestange
2 Knoblauchzehen
2 Zweige Rosmarin
3 Kartoffeln
150 ml Olivenöl Extra Vergine
150 ml Weißwein

Karotte und Sellerie in sehr kleine Streifen schneiden, auf einem Backblech verteilen und mit Olivenöl übergießen. Die Lammhaxe mit Knoblauch und Rosmarin beizen und auf das Ge-müsebett legen. Mit Salz und Pfeffer würzen sowie erneut mit Knoblauch, Salz und Rosmarin beizen. Mit Öl begießen und bei 180 °C backen lassen. Nach 10 Minuten den Weißwein darübergießen und 30 Minuten weiterbacken lassen. Danach die gepellten und in Würfel geschnittenen Kartoffeln hinzugeben und weitere 20 Minuten backen lassen.

Servieren: Im ganzen Stück servieren und mit Karotte, frischem Sellerie und einem Zweig Rosmarin krönen. Abschließend mit einem Schuss Öl verfeinern.

1 épaule d'agneau
1 carotte
1 branche de céleri
2 pointes d'ail
2 brins de romarin
3 pommes de terre
150 ml d'huile d'olive vierge extra
150 ml de vin blanc

Dans un plat à gratin avec l'huile d'olive, disposer les carottes et le céleri émincés en julienne. Assaisonner l'épaule d'agneau avec l'ail et le romarin et la disposer sur le lit de légumes. Saler et poivrer puis assaisonner avec l'ail, le sel et le romarin. Arroser d'huile et enfourner à 180 °C. Après 10 minutes, arroser de vin blanc. Poursuivre la cuisson 30 minutes, puis ajouter les pommes de terre épluchées et détaillées en dés. Laisser au four 20 minutes additionnelles. Présentation : Servir entier et couronner de la carotte et du céleri frais ainsi que d'une branche de romarin. Décorer d'un trait d'huile crue.

1 pata de cordero
1 zanahoria
1 rama de apio
2 dientes de ajo
2 ramitas de romero
3 patatas
150 ml de aceite de oliva virgen extra
150 ml de vino blanco

Disponer en una fuente de horno con aceite de oliva las zanahorias y el apio cortados en julia-na. Adobar la pierna de cordero con ajo y romero y colocarla sobre el lecho de verduras. Condimentar con sal y pimienta y adobar con ajo, sal y romero. Rociar con aceite y hornear a 180 °C. Después de 10 minutos, rociar con vino blanco. Continuar la cocción durante otros 30 minutos, luego agregar las patatas peladas y cortadas en dados. Hornear 20 minutos más. Emplatado: Servir entero y coronar con zanahoria y apio frescos y una ramita de romero. Decorar con un chorro de aceite crudo.

# Hostaria dell'Orso

Design: Francesco Giuliano | Chef: Gualtiero Marchesi,
Sergio Ippolito

Via dei Soldati 25C | 00186 Rome
Phone: +39 06 68301192
www.hostariadellorso.it
Subway: Spagna
Opening hours: Mon–Sat 8 pm to 1 pm
Average price: € 85
Cuisine: Traditional Italian, reworked
Special features: Rome's oldest small hotel, in a building that dates back to 1400, is
now owned by renowned chef Gualtiero Marchesi; formerly an inn for pilgrims

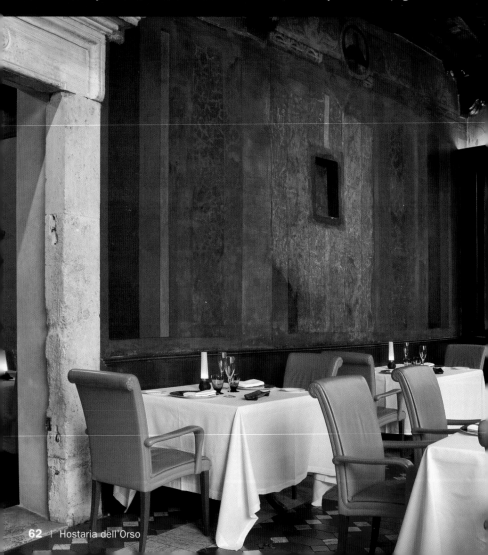

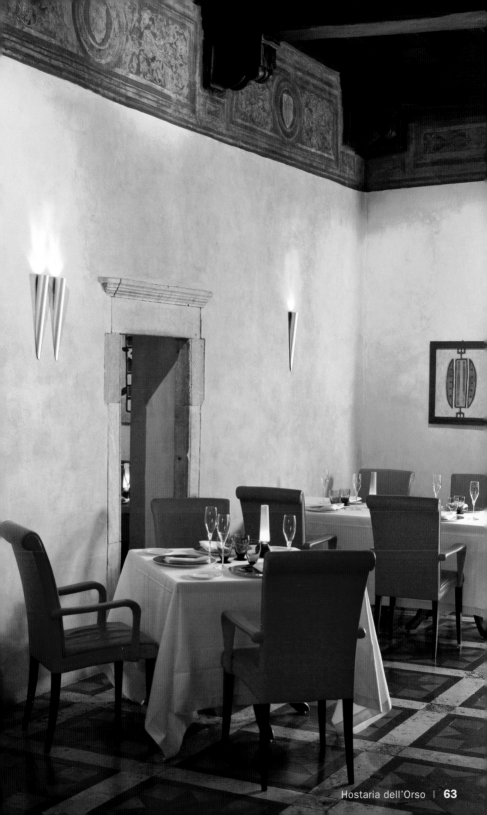

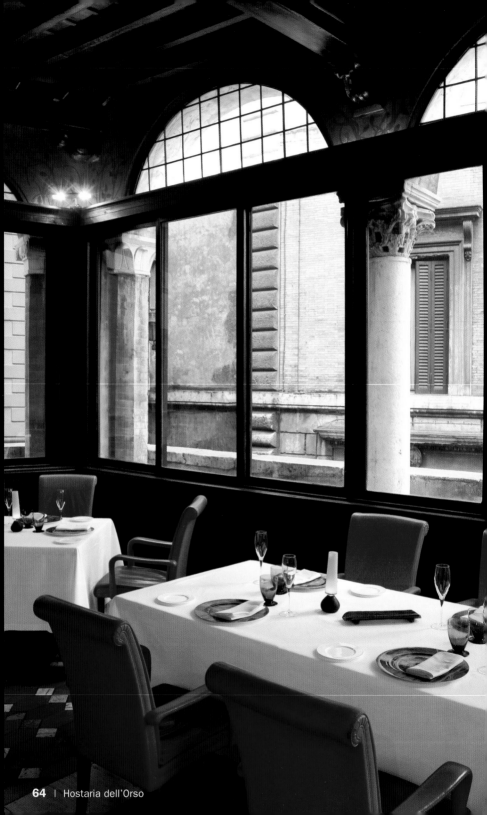

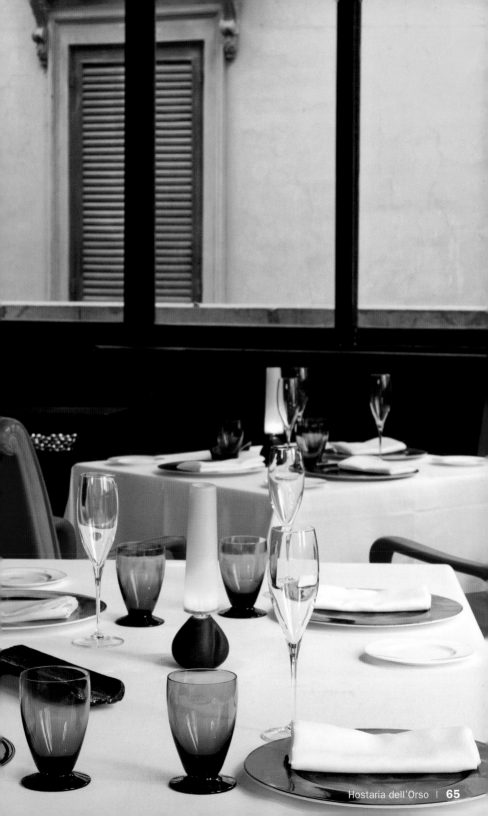

# Tonno
## alla piastra

Grilled Tuna
Gegrillter Thunfisch
Thon grillé
Atún a la plancha

400 g di filetti di tonno fresco
200 g di pomodori ramati
100 g di olive nere snocciolate
100 ml di olio extra vergine di oliva
200 ml di olio di semi
5 g di pepe nero in grani
9 fogli di pasta filo
3 rametti di timo

In una padella con olio di semi, friggere i fogli di pasta filo. Ritirarli e sistemarli su della carta da cucina per eliminare l'olio in eccesso. Lasciare a riposo. Tagliare i pomodori a pezzetti, frullarli e scolarli per eliminare i semi. Aggiungere un filo di olio di oliva, cospargere di pepe macinato, correggere di sale e mettere da parte. Frullare le olive snocciolate, cospargerle di pepe, salare e amalgamare con dell'olio di oliva. Mettere da parte. Cuocere i filetti di tonno sulla piastra e salare.
Presentazione: Sul bordo di un piatto piano, sistemare le salse delle olive e dei pomodori in cerchi concentrici. Al centro, disporre alternatamente i filetti di tonno e i fogli di pasta filo. Adornare con dei rametti di timo.

14 oz fresh tuna fillets
7 oz fresh tomatoes
3 1/2 oz pitted black olives
100 ml extra virgin olive oil
200 ml seed oil
1/6 oz ground black pepper
9 sheets of phyllo pasta
3 springs of thyme

Fry the phyllo pasta in a skillet with seed oil. Remove and place on kitchen towels to soak up excess oil. Set aside. Slice the tomatoes, squeeze, and strain to remove seeds. Add a squirt of olive oil, sprinkle with ground pepper, and adjust salt. Set aside. Squeeze the pitted olives, sprinkle with pepper, add salt, and mix with olive oil. Set aside. Grill the tuna fillets and add salt.
Presentation: On the edge of a flat plate, place the olive and tomato sauces in concentric circles. In the center of the plate, alternate the tuna fillets and phyllo pasta. Garnish with sprigs of thyme.

400 g frische Thunfischfilets
200 g Strauchtomaten
100 g entkernte schwarze Oliven
100 ml Olivenöl Extra Vergine
200 ml Samenöl
5 g schwarze Pfefferkörner
9 Blätter Filo-Teig
3 Thymianzweige

Den Filo-Teig in einer Pfanne mit Samenöl braten, abtropfen lassen und auf Küchenpapier legen, damit das überschüssige Öl aufgenommen werden kann. Danach beiseite stellen. Die Tomaten in Stücke schneiden, auspressen und die Kerne heraussieben. Einen Schuss Olivenöl dazugeben, mit Salz und gemahlenem Pfeffer bestreuen und beiseite stellen. Die entkernten Oliven ebenfalls auspressen, Pfeffer darüber streuen, salzen und mit dem Olivenöl vermengen. Die Mischung danach beiseite stellen. Die Thunfischfilets in einer Grillpfanne braten und salzen.
Servieren: Die Soße aus Oliven und Tomaten am Rand eines flachen Tellers kreisförmig anrichten. In der Tellermitte abwechselnd die Thunfischfilets und die Filo-Teig-Scheiben platzieren. Abschließend mit den Thymianzweigen dekorieren.

400 g de filets de thon frais
200 g de tomates en branche
100 g d'olives noires dénoyautées
100 ml d'huile d'olive vierge extra
200 ml d'huile végétale
5 g de poivre noir en grains
9 feuilles de pâte filo
3 branches de thym

Faire frire les feuilles de pâte filo dans une poêle avec l'huile végétale. Les retirer et les disposer sur du essuie-tout afin d'éliminer l'excès d'huile. Réserver. Couper les tomates, les centrifuger et les passer au chinois pour éliminer les pépins. Ajouter une pointe d'huile d'olive, saupoudrer de poivre moulu et saler selon le goût. Réserver. Mixer les olives dénoyautées, les saupoudrer de poivre, saler et amalgamer à l'huile d'olive. Réserver. Passer les filets de thon au grill et les saler.
Présentation : Au bord du plat de service, disposer les sauces d'olive et de tomate en cercles concentriques. Au centre du plat, faire alterner les filets de thon et les feuilles de pâte filo. Décorer avec les branches de thym.

400 g de filetes de atún fresco
200 g de tomates de rama
100 g de aceitunas negras deshuesadas
100 ml de aceite de oliva virgen extra
200 ml de aceite de semillas
5 g de pimienta negra en granos
9 hojas de pasta filo
3 ramitas de tomillo

En una sartén con aceite de semillas, freír las hojas de pasta filo. Sacarlas y colocarlas sobre papel de cocina para eliminar el exceso de aceite. Reservar. Cortar los tomates en trozos, licuarlos y colarlos para eliminar las semillas. Añadir un chorro de aceite de oliva, espolvorear con la pimienta molida y ajustar de sal. Reservar. Licuar las aceitunas deshuesadas, espolvorear con la pimienta, salar y amalgamar con aceite de oliva. Reservar. Pasar los filetes de atún por la plancha y salar.
Emplatado: En el borde de un plato llano, colocar las salsas de aceitunas y tomate en círculos concéntricos. En el centro del plato, disponer alternadamente los filetes de atún y las hoja de pasta de filo. Adornar con las ramitas de tomillo.

# Hosteria del Pesce

Design: Hosteria del Pesce I Chef: Fabio di Felice

Via di Monserrato 32 I 00186 Rome
Phone: +39 06 6865617
Opening hours: Mon–Sat 7 pm to midnight
Average price: € 50
Cuisine: Specializing in fish

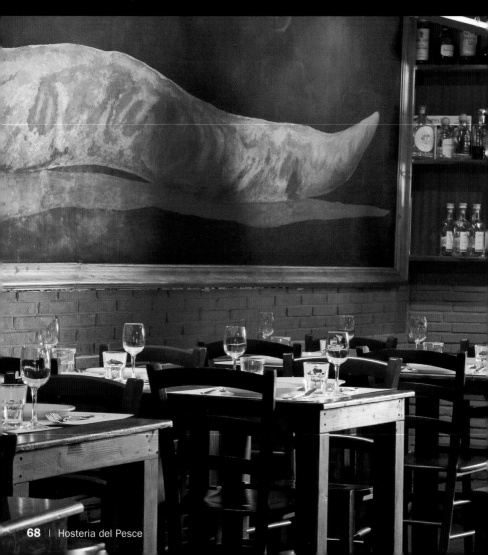

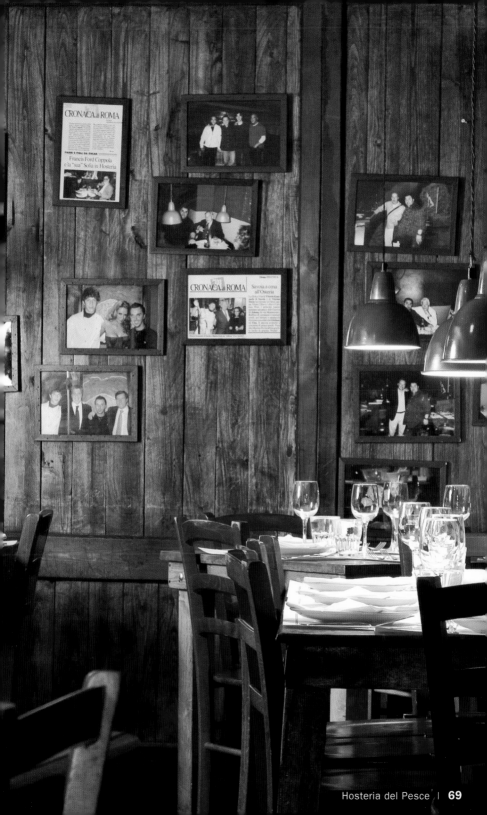

# Paccheri
## con calamaretti

Paccheri with small squids
Paccheri mit kleinen Tintenfischen
Paccheri aux petits calmars
Paccheri con calamarcitos

100 g di paccheri
100 g di calamaretti
200 ml di olio extra vergine di oliva
150 ml di vino bianco
1 spicchio d'aglio
1 rametto di prezzemolo
1 rametto di basilico
1 peperoncino rosso

In una padella con olio e uno spicchio d'aglio, saltare i calamaretti a fuoco alto fino a farli dorare, e poi cospargerli di vino bianco. Lasciare evaporare il vino per 2 minuti, dopodiché aggiungere il prezzemolo triturato, alcune foglie di basilico e il peperoncino rosso, e correggere di sale. Mettere da parte. In una pentola con acqua abbondante, cuocere i paccheri per 10 minuti, scolarli e bagnarli con un filo di olio.
Presentazione: Prima di servire, versare i paccheri nella padella e amalgamare con la salsa. Servire caldo in un piatto fondo e decorare con rametti freschi di prezzemolo.

3 1/2 oz paccheri
3 1/2 oz small squids
200 ml extra virgin olive oil
150 ml white wine
1 clove of garlic
1 sprig of parsley
1 sprig of basil
1 red chili

In a skillet, sauté the squids in oil with a clove of garlic over high heat until golden brown. Moisten with white wine. Allow the wine to evaporate for 2 minutes, then add the chopped parsley, a few basil leaves, and the chili, and adjust the salt. Set aside. In a pot with a generous amount of water, cook the paccheri for 10 minutes, drain, and drizzle oil on top.
Presentation: Before serving, turn the paccheri into the skillet and add the sauce. Serve warm in a deep dish and garnish with springs of fresh parsley.

100 g Paccheri (Röhrchennudeln)
100 g kleine Tintenfische
200 ml Olivenöl Extra Vergine
150 ml Weißwein
1 Knoblauchzehe
1 Bund Petersilie
1 Basilikumzweig
1 Chilischote

Öl und Knoblauchzehe in eine Pfanne geben, die kleinen Tintenfische darin auf hoher Flamme anbraten und den Weißwein hinzugießen. Den Wein in 2 Minuten verdampfen lassen, die gehackte Petersilie, einige Basilikumblätter und die Chilischote hinzugeben, mit Salz würzen und beiseite stellen. Die Paccheri in einem Topf mit reichlich Wasser 10 Minuten lang kochen, abtropfen lassen und mit einem Schuss Öl verfeinern.
Servieren: Vor dem Servieren die Paccheri in der heißen Pfanne verteilen und mit der Soße vermengen. Auf einem tiefen Teller heiß servieren und mit frischer Petersilie dekorieren.

100 g de paccheri
100 g de petits calmars
200 ml d'huile d'olive vierge extra
150 ml de vin blanc
1 pointe d'ail
1 branche de persil
1 brin de basilic
1 chili rouge

Dans une poêle avec de l'huile et une pointe d'ail, faire sauter les petits calmars à feu vif pour les dorer. Les mouiller avec le vin blanc. Laisser s'évaporer le vin durant 2 minutes puis ajouter le persil haché, quelques feuilles de basilic et le chili. Saler selon le goût. Réserver. Dans une casserole avec de l'eau en abondance, cuire les paccheri 10 minutes, les égoutter et mouiller d'un trait d'huile.
Présentation : Avant de servir, verser les paccheri dans la poêle et mélanger avec la sauce. Servir chaud dans un plat creux et décorer de brins de persil frais.

100 g de paccheri
100 g de calamarcitos
200 ml de aceite de oliva virgen extra
150 ml de vino blanco
1 diente de ajo
1 ramillete de perejil
1 ramita de albahaca
1 guindilla

En una sartén con aceite y un diente de ajo, saltear los calamarcitos a fuego fuerte hasta dorarlos y mojarlos con vino blanco. Dejar evaporar el vino durante 2 minutos, luego añadir el perejil triturado, unas hojas de albahaca y la guindilla y ajustar de sal. Reservar. En una cazuela con abundante agua, cocer los paccheri durante 10 minutos, escurrir y mojar con un chorro de aceite.
Emplatado: Antes de servir, verter los paccheri en la sarten y amalgamar con la salsa. Servir caliente en plato hondo y adornar con ramitas frescas de perejil.

# Ketumbar

Design: Stefano Tanoni I Chef: Fabricio Fiatucci

Via Galvani 24 I 00153 Rome
Phone: +39 06 57305338
www.ketumbar.it
Subway: Piramide
Opening hours: Mon–Sun 8 pm to midnight
Average price: € 30
Cuisine: Creative Italian-Asian fusion
Special features: Situated in one of the oldest buildings in Testaccio, combines East
and West through cuisine and decor

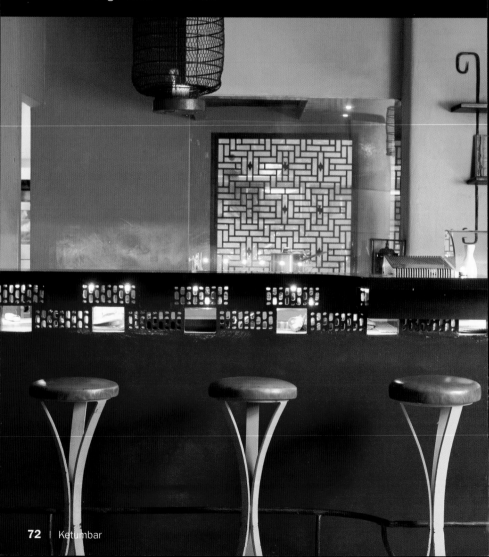

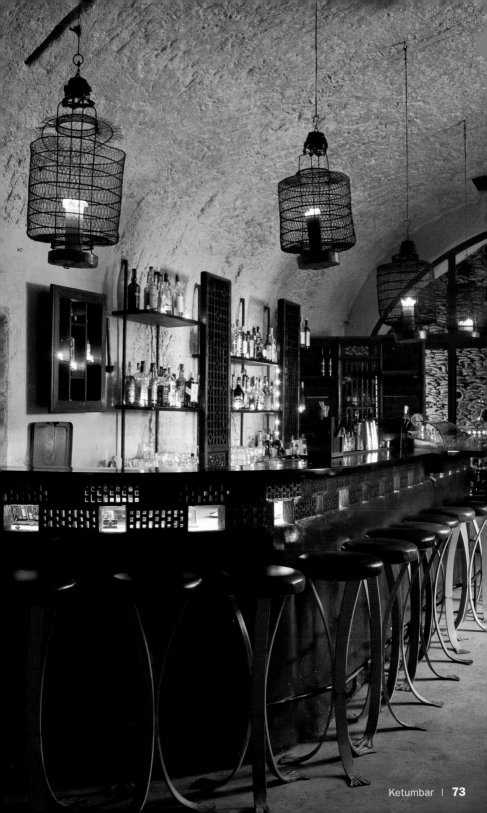

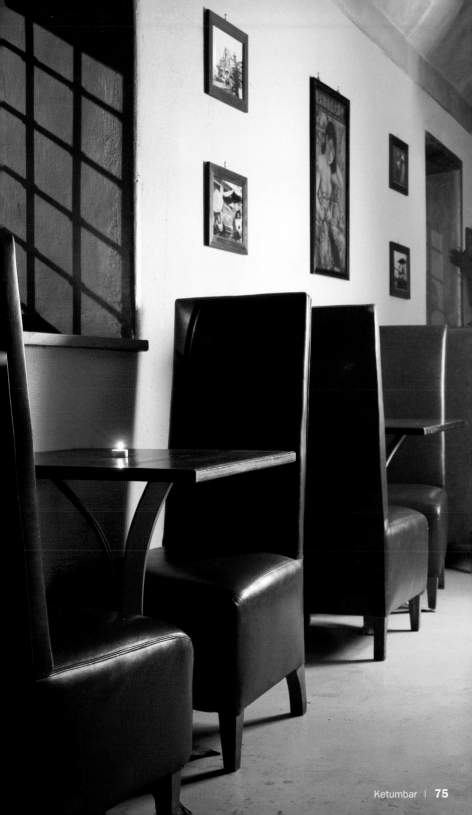

# Nasi Goreng

Nasi Goreng
Nasi Goreng
Nasi Goreng
Nasi Goreng

120 g di verdure (carota, zucchina e verza bianca)
150 g di riso basmati
1 uovo
30 ml di salsa di soia
1 pizzico di curcuma

In una pentola con acqua, far cuocere le verdure per 4 minuti, aggiungere un uovo e rimuovere il preparato fino a che l'uovo non sia cotto. Ritirare dal fuoco. In una casseruola a parte cuocere il riso basmati previamente tostato. Versare il riso e il preparato in una padella e saltare per alcuni minuti.
Presentazione: Riempire una tazza con parte del preparato e girarla su un vassoio creando piccoli monticelli di riso. Cospargere con la salsa di soia e aggiungere la curcuma.

4 oz vegetables (carrot, zucchini, and white cabbage)
5 oz basmati rice
1 egg
30 ml soy sauce
1 pinch turmeric

In a pot, cook the vegetables in water for 4 minutes, add an egg and stir the mixture until the egg is cooked. Remove from heat. In a pot, cook the basmati rice (toasted in advance). Remove the rice and the vegetables to a skillet and sauté for a few minutes.
Presentation: Fill a cup with part of the mixture and turn onto a plate, making small mounds of rice. Drizzle with soy sauce and add the turmeric.

120 g Gemüse (Karotte, Zucchini und weißer Kohl)
150 g Basmatireis
1 Ei
30 ml Sojasoße
1 Prise Kurkuma

Das Gemüse in einem Topf 4 Minuten lang in Wasser kochen, ein Ei hinzugeben und solange umrühren, bis das Ei gekocht ist und danach beiseite stellen. In einem Topf den vorher angerösteten Basmatireis kochen. Den Reis gemeinsam mit der Gemüsemischung in eine Pfanne geben und einige Minuten anbraten.
Servieren: Eine Tasse mit Teilen der zubereiteten Mischung füllen und auf einen kleinen Teller stürzen, so dass kleine Reishügel entstehen. Mit der Sojasoße übergießen und mit Kurkuma bestreuen.

120 g de légumes (carotte, courgette et chou blanc)
150 g de riz basmati
1 œuf
30 ml de sauce soja
1 pincée de curcuma

Dans une casserole d'eau, cuire les légumes durant 4 minutes, ajouter l'œuf et remuer jusqu'à ce que l'œuf soit cuit. Retirer. Dans un autre casserole, cuire le riz basmati préalablement grillé. Verser le riz et la préparation dans une poêle et faire sauter pendant quelques minutes.
Présentation : Remplir une tasse avec une partie de la préparation et la retourner sur un plat pour former de petits monticules de riz. Arroser avec la sauce soja et ajouter le curcuma.

120 g de verduras (zanahoria, calabacín y berza blanca)
150 g de arroz basmati
1 huevo
30 ml de salsa de soja
1 pizca de cúrcuma

En una cacerola con agua, cocer las verduras durante 4 minutos, añadir un huevo y remover el preparado hasta que se haga el huevo. Retirar. En una cazuela aparte cocer el arroz basmati previamente tostado. Verter el arroz y el preparado en una sartén y saltear durante unos minutos.
Emplatado: Llenar una taza con parte del preparado y darle la vuelta sobre una fuente creando pequeños montículos de arroz. Rociar con la salsa de soja y añadir la cúrcuma.

# Le Bain

Design: Fabio Cialfa | Chef: Vito Grossano

Via delle Botteghe Oscure 33 | 00186 Rome
Phone: +39 06 6865673
www.lebain.it
Subway: Colosseo
Opening hours: Mon–Sat 12:30 pm to 3:30 pm, 8:30 pm to midnight
Average price: € 25
Cuisine: Creative regional Italian cuisine
Special features: Restaurant and wine cellar; on lunchtime open buffet with
vegetables, rice, and pasta

# Baccalà

## con patate

Codfish with Potatoes
Kabeljau mit Kartoffeln
Morue aux pommes de terre
Bacalao con patatas

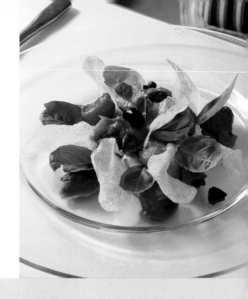

500 g di baccalà
4 patate
4 pomodorini maturi
300 ml di latte
200 ml di olio extra vergine di oliva
20 g di capperi
50 g di olive nere
8 foglie di basilico

Dissalare il baccalà in acqua per due giorni, cambiando l'acqua ogni 4 ore. Pulirlo, togliere le spine e la pelle e tagliarlo a pezzi. In una padella con un po' di olio di oliva, mettere i pezzi di baccalà e 3 patate tagliate a cubetti. Far dorare per 6 minuti, dopodiché aggiungere il latte e far cuocere per 20 minuti. Versare il preparato in una ciotola profonda, aggiungere un filo di olio di oliva e montarlo con le fruste elettriche fino a che non diventi spumoso. Mettere da parte. In una padella con olio, saltare i capperi, le olive snocciolate e i pomodori tagliati a metà per 5 minuti. Mettere da parte. Tagliare una patata a fettine sottili e friggere fino a che queste non diventino croccanti.
Presentazione: Disporre il preparato di baccalà al centro del piatto, coronare con la salsa di pomodoro e decorare con foglie di basilico e fettine di patata croccanti.

18 oz codfish
4 potatoes
4 small ripe tomatos
300 ml milk
200 ml extra virgin olive oil
2/3 oz capers
1 3/4 oz black olives
8 basil leaves

Desalt the codfish in water for two days, being careful to change the water every 4 hours. Clean it, remove the bones and skin, cutting it into pieces. Place the codfish pieces and 3 potatoes, cut into small cubes, in a skillet with a little olive oil. Brown for 6 minutes, then add the milk and cook 20 minutes more. Turn the mixture into a bowl, squirt with olive oil, and whisk until frothy. Set aside. In a skillet, sauté the capers, pitted olives, and halved tomatoes in oil for 5 minutes. Set aside. Finely slice a potato and fry the slices until crisp.
Presentation: Place the cod mixture in the center of the plate, top with the tomato sauce, and garnish with basil leaves and crisp potato slices.

500 g Kabeljau
4 Kartoffeln
4 kleine reife Tomaten
300 ml Milch
200 ml Olivenöl Extra Vergine
20 g Kapern
50 g schwarze Oliven
8 Basilikumblätter

Den Kabeljau zwei Tage lang im Wasserbad entsalzen. Dabei sollte das Wasser alle 4 Stunden gewechselt werden. Den Kabeljau anschließend säubern sowie Gräten und Haut entfernen und in Stücke schneiden. Kabeljau und die in kleine Würfel geschnittenen 3 Kartoffeln in eine Pfanne mit Olivenöl geben und 6 Minuten anbraten. Danach die Milch dazugießen und 20 Minuten weiterkochen lassen. Die Mischung in eine Schüssel umfüllen, einen Schuss Olivenöl dazugeben, mit einem Mixer schaumig schlagen und beiseite stellen. Kapern, entkernte Oliven und 4 halbierte Tomaten mit Öl in einer Pfanne 5 Minuten lang sautieren und beiseite stellen. Eine Kartoffel in hauchdünne Scheiben schneiden und knusprig braten.
Servieren: Die Kabeljaumischung in der Tellermitte verteilen, mit der Tomatensoße krönen und mit Basilikumblättern sowie Bratkartoffelscheiben garnieren.

1 morue de 500 g
4 pommes de terre
4 petites tomates mûres
300 ml de lait
200 ml d'huile d'olive vierge extra
20 g de câpres
50 g d'olives noires
8 feuilles de basilic

Dessaler la morue dans l'eau durant deux jours en prenant soin de changer l'eau toutes les 4 heures. La laver, retirer les arêtes et la peau et tronçonner. Dans une poêle avec un peu d'huile d'olive, ajouter les morceaux de morue et 3 pommes de terre détaillées en petits dés. Faire dorer 6 minutes puis ajouter le lait et laisser cuire 20 minutes. Verser la préparation dans un plat creux, ajouter un trait d'huile et monter au fouet pour obtenir un mélange mousseux. Réserver. Dans une poêle avec de l'huile, faire sauter les câpres, les olives dénoyautées et les tomates coupées en deux durant 5 minutes. Réserver. Émincer finement une pomme de terre et faire frire pour qu'elle soit croquante.
Présentation : Disposer la préparation de morue au centre du plat, couronner avec la sauce tomate et décorer avec des feuilles de basilic et des chips de pomme de terre.

500 g de bacalao
4 patatas
4 tomates pequeños maduros
300 ml de leche
200 ml de aceite de oliva virgen extra
20 g de alcaparras
50 g de aceitunas negras
8 hojas de albahaca

Desalar el bacalao en agua durante dos días cuidando de cambiar el agua cada 4 horas. Limpiarlo, quitar las espinas y la piel y cortarlo en trozos. En una sartén con un poco de aceite de oliva, echar los trozos de bacalao y 3 patatas cortadas en cubitos pequeños. Dorar durante 6 minutos, luego añadir la leche y dejar cocer durante 20 minutos. Verter el preparado en un cuenco, añadir un chorro de aceide de oliva y montarlo con la varilla hasta que esté espumoso. Reservar. En una sartén con aceite, saltear las alcaparras, las aceitunas deshuesadas y los tomates cortados por la mitad durante 5 minutos. Reservar. Cortar una patata en láminas finas y freír hasta que estén crujientes.
Emplatado: Colocar el preparado de bacalao en el centro del plato, coronar con la salsa de tomate y adornar con hojas de albahaca y láminas de patata crujientes.

# Mezzo

Design: ID4 | Chef: Coletta Moreno

Via di Priscilla 25A | 00199 Rome
Phone: +39 06 8639901
Opening hours: Mon–Sun 12 pm to midnight
Average price: € 30
Cuisine: Mediterranean cuisine

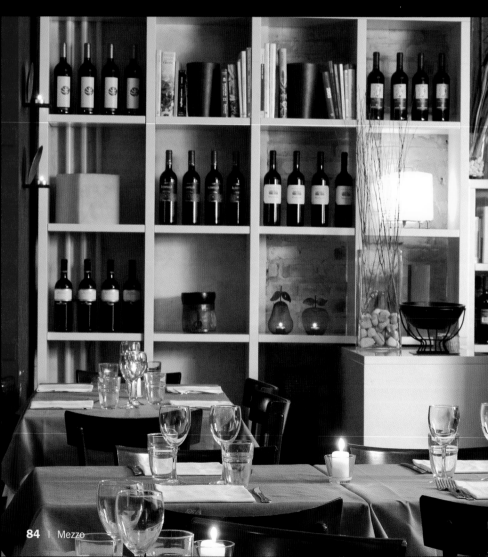

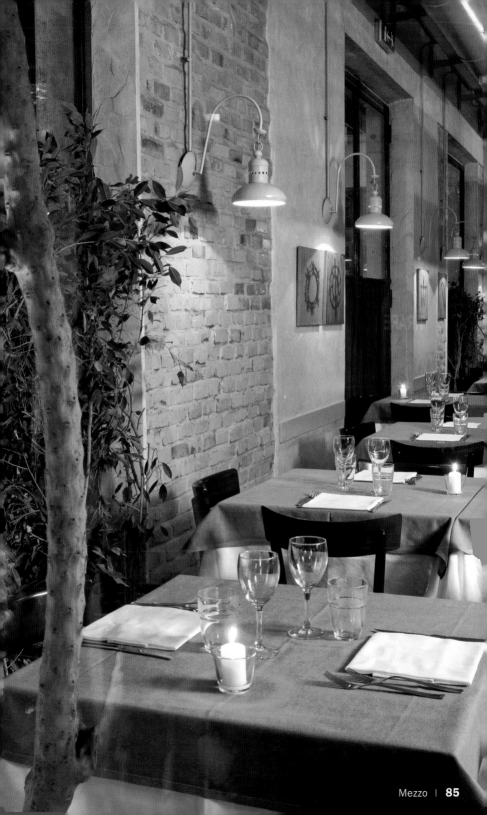

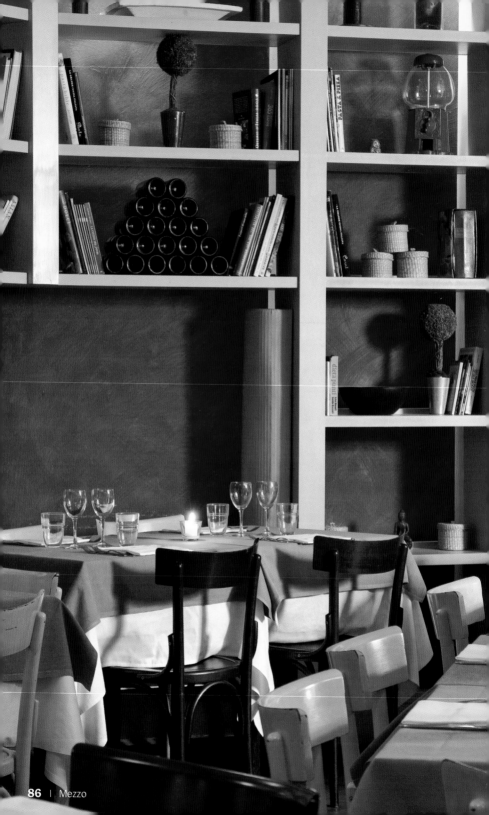

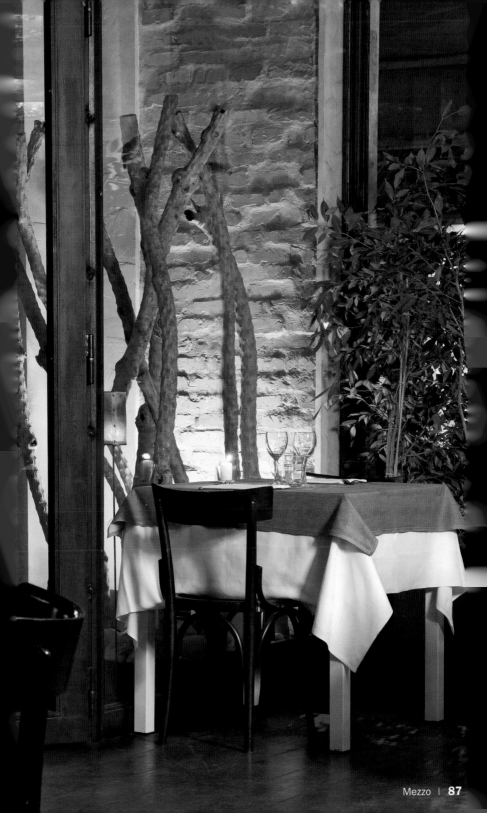

# Faraona
## al sesamo

Sesame Guinea Fowl
Perlhuhn mit Sesam
Pintade aux graines de sésame
Pintada al sésamo

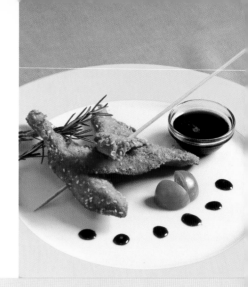

200 g di petti di faraona
100 g di pangrattato
100 g di sesamo
150 ml di olio extra vergine di oliva
3 uova
200 g di soia
100 ml di aceto balsamico
100 g di zucchero
1 pomodoro maturo piccolo
Rosmarino

In un tegame, versare l'aceto balsamico e lo zucchero e far cuocere per 5 minuti. Aggiungere la soia e ridurre il preparato a fuoco lento per 30 minuti. Sbattere le uova in un piatto fondo, tagliare i petti a strisce, spolverizzarle con pangrattato e bagnarle leggermente nell'uovo. In una padella, tostare i semi di sesamo. Impanare i petti di faraona nel sesamo e friggerli.
Presentazione: Servire i petti caldi in un piatto con la salsa di sesamo a parte. Decorare con un rametto di rosmarino e un pomodoro maturo tagliato a metà.

7 oz guinea fowl breasts
3 1/2 oz bread crumbs
3 1/2 oz sesame seeds
150 ml extra virgin olive oil
3 eggs
7 oz soy
100 ml balsamic vinegar
3 1/2 oz sugar
1 small ripe tomato
Rosemary

Place the balsamic vinegar and sugar in a casserole and cook for 5 minutes. Add the soy and reduce over low heat for 30 minutes. Whisk the eggs in a deep bowl, cut the breasts into strips, coat with bread crumbs, and dip in the egg. In a skillet, toast the sesame seeds. Coat the breasts with the sesame seeds and fry.
Presentation: Serve the breasts warm on a plate with the soy sauce on the side. Garnish with a sprig of rosemary and a halved ripe tomato.

200 g Perlhuhnbrust
100 g Semmelbrösel
100 g Sesamsamen
150 ml Olivenöl Extra Vergine
3 Eier
200 g Sojabohnen
100 ml Balsamico-Essig
100 g Zucker
1 kleine reife Tomate
Rosmarin

Balsamico-Essig und Zucker in eine Kasserolle geben und 5 Minuten lang kochen. Die Sojabohnen hinzugeben und kleiner Flamme 30 Minuten weiter kochen lassen. Eier in einen tiefen Teller schlagen, Geflügelbrust in Streifen schneiden, Semmelbrösel darüber streuen und mit den Eiern vermengen. Sesamsamen in einer Pfanne rösten, die Geflügelbruststreifen mit den Sesamsamen panieren und anschließend durchbraten.
Servieren: Die heiße Geflügelbrust auf einem Teller drapieren und die Sesamsoße separat servieren. Mit dem Rosmarinzweig und den beiden Hälften einer reifen Tomate dekorieren.

200 g de blanc de pintade
100 g de chapelure
100 g de graines de sésame
150 ml d'huile d'olive vierge extra
3 œufs
200 g de soja
100 ml de vinaigre balsamique
100 g de sucre
1 petite tomate mûre
Romarin

Dans une casserole, verser le vinaigre balsamique et le sucre et faire cuire 5 minutes. Ajouter le soja et laisser réduire à feu lent pendant 30 minutes. Battre les œufs dans un plat creux, couper les blancs en lanières, les saupoudrer de chapelure et les passer dans l'œuf. Dans une poêle, faire griller les graines de sésame. Enrober les blancs avec les graines de sésame et les faire frire.
Présentation : Servir les blancs bien chauds dans un plat, avec la sauce sésame à part. Décorer d'un brin de romarin et d'une tomate mûre coupée en deux

200 g de pechugas de pintada
100 g de pan rallado
100 g de sésamo
150 ml de aceite de oliva virgen extra
3 huevos
200 g de soja
100 ml de vinagre balsámico
100 g de azúcar
1 tomate maduro pequeño
Romero

En una cazuela, verter el vinagre balsámico y el azúcar y cocer durante 5 minutos. Añadir la soja y reducir el preparado a fuego lento durante 30 minutos. Batir los huevos en un plato hondo, cortar la pechugas en tiras, espolvorearlas con pan rallado y pasarlas por el huevo. En una sartén, tostar las semillas de sésamo. Rebozar las pechugas en el sésamo y freírlas.
Emplatado: Servir las pechugas calientes en un plato con la salsa de sésamo aparte. Decorar con una ramita de romero y un tomate maduro cortado por la mitad.

# Moma

Design: Maurizio Papiri | Chef: Franco Pierini

Via San Basilio 42–43 | 00187 Rome
Phone: +39 06 42011798
Subway: Barberini
Opening hours: Mon–Sun 12:30 pm to 3:30 pm, 8 pm to 11:30 pm
Average price: € 30
Cuisine: A modern take on traditional and international cuisine
Special features: Moma is a restaurant, wine bar, and cigar room

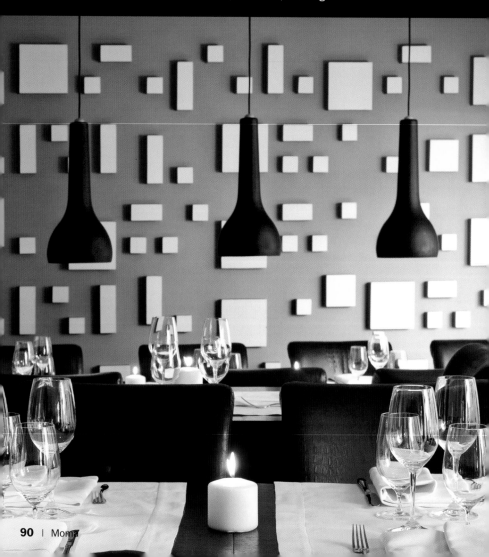

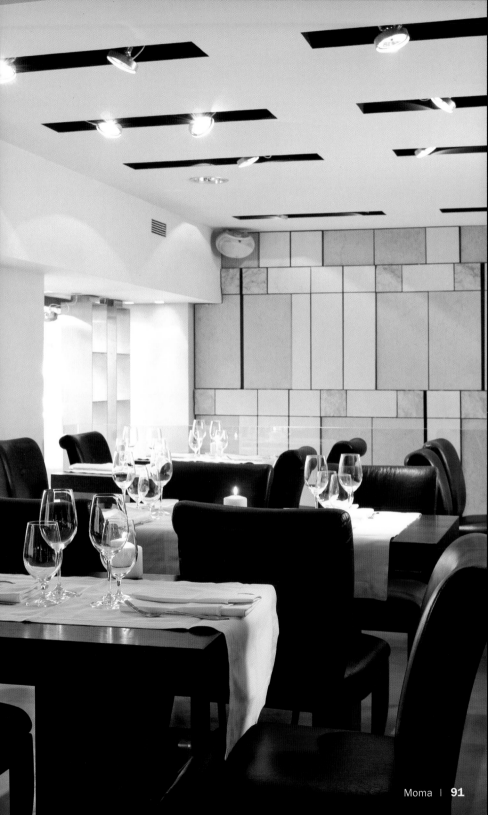

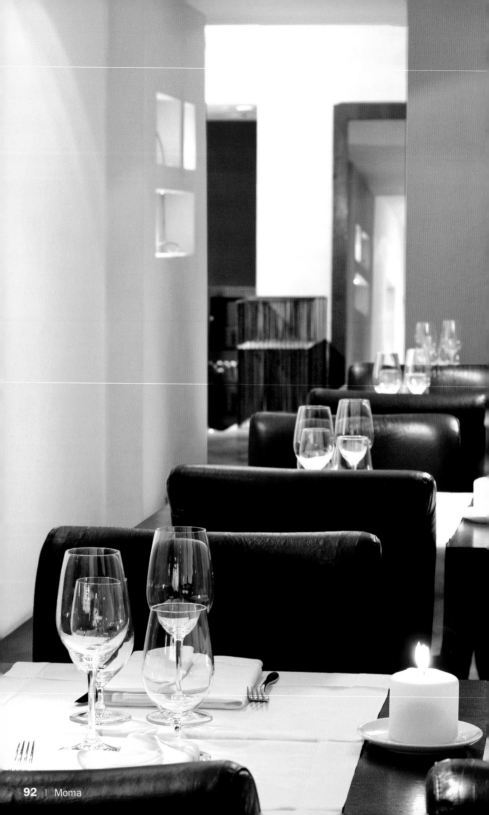

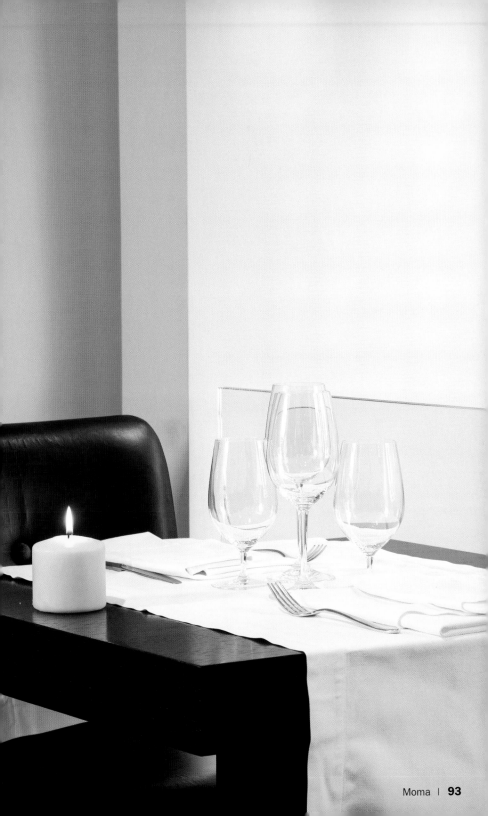

# Montecarlo

Design: Alfredo Martiriggiano, Aldelio Pucci | Chef: Luigi Pucci

Piazza Mastai 1 | 00153 Rome
Phone: +39 06 5819870
Subway: Ostiense
Opening hours: Mon–Sun 12:30 pm to 3:30 pm, 7:30 pm to 12:45 am
Average price: € 25
Cuisine: Traditional Roman
Special features: Highly original, painstaking decor

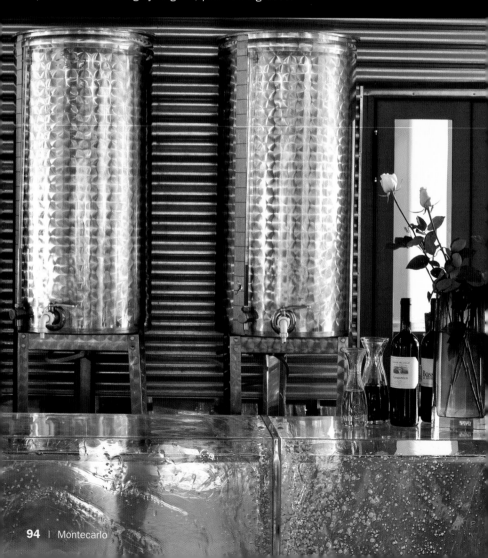

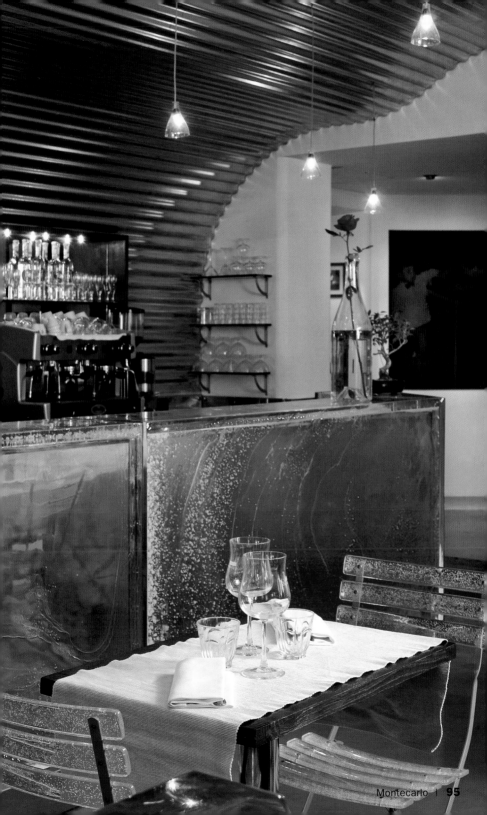

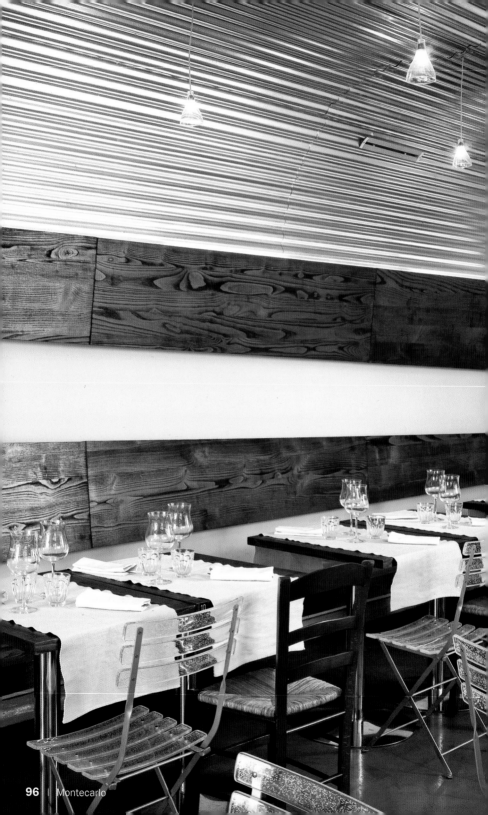

# Mezze maniche

## all'amatriciana

Mezze maniche a la amatriciana
Mezze Maniche a la amatriciana
Mezze maniche à la amatriciana
Mezze maniche a la amatriciana

100 g di mezze maniche
50 g di pancetta di maiale
50 g di pomodori triturati
2 peperoncini rossi
100 ml di vino bianco
100 g di formaggio di pecora stagionato
50 ml di olio extra vergine di oliva

In una padella con dell'olio, soffriggere i peperoncini rossi e la pancetta tagliata a dadini fino a farla dorare. Spruzzarvi un po' di vino, ridurre per alcuni minuti dopodiché unire il pomodoro triturato. Cuocere il preparato per 10 minuti e poi lasciarlo a riposo. In una pentola con molta acqua, cuocere la pasta per 8 minuti, scolarla e versarla nella padella. Aggiungere il formaggio di pecora e amalgamare.
Presentazione: Servire caldo in un piatto piano, spolverizzare con formaggio grattugiato e decorare con delle fettine di pancetta.

3 1/2 oz mezze maniche
1 3/4 oz bacon
1 3/4 oz crushed tomatoes
2 red chilis
100 ml of white wine
3 1/2 oz cured sheep's milk cheese
50 ml extra virgin olive oil

In a skillet, sauté the chilis and the bacon, cut into squares, in oil until golden brown. Drizzle with wine, reduce for a few minutes, and add the crushed tomatoes. Cook for 10 minutes. Set aside. In a pot with a generous amount of water, cook the pasta for 8 minutes, drain and turn into the skillet. Add the grated sheep's milk cheese and mix.
Presentation: Serve warm on a flat plate, sprinkle with grated cheese and garnish with bacon slices.

100 g Mezze Maniche
50 g Schinkenspeck
50 g pürierte Tomaten
2 rote Chilischoten
100 ml Weißwein
100 g harter Schafskäse
50 ml Olivenöl Extra Vergine

Die Chilischoten und den gewürfelten Schinken-speck in einer Pfanne mit Öl anbraten. Mit dem Wein übergießen, einige Minuten die Flamme kleiner stellen und die pürierten Tomaten hinzu-geben. Die Mischung 10 Minuten lang kochen lassen und anschließend beiseite stellen. Die Nudeln 8 Minuten lang in einem Topf mit viel Wasser kochen, Flüssigkeit abgießen und in der Pfanne verteilen. Den geriebenen Schafskäse hinzugeben und gut vermischen.
Servieren: In einem flachen Teller heiß servie-ren, mit Käseraspeln bestreuen und dünnen Speckstreifen garnieren.

100 g de mezze maniche
50 g de lard de cochon
50 g de tomates concassées
2 chilis rouges
100 ml de vin blanc
100 g de fromage de chèvre affiné
50 ml d'huile d'olive vierge extra

Dans une poêle avec de l'huile, faire revenir les chilis et le lard coupés en dés pour le dorer. Ar-roser de vin, faire réduire quelques minutes puis ajouter la sauce tomate. Faire cuire la prépara-tion 10 minutes. Réserver. Dans une casserole avec beaucoup d'eau, faire cuire les pâtes 8 mi-nutes, les égoutter et les verser dans la poêle. Ajouter le fromage de chèvre râpé et l'amalga-mer.
Présentation : Servir chaud dans un plat de ser-vice, saupoudrer de fromage râpé et décorer avec des tranches de lard.

100 g de mezze maniche
50 g de tocino de cerdo
50 g de tomates triturados
2 guindillas
100 ml de vino blanco
100 g de queso de oveja curado
50 ml de aceite de oliva virgen extra

En una sartén con aceite, sofreír las guindillas y el tocino cortado en dados hasta dorarlo. Rociar con vino, reducir durante unos minutos y agre-gar el tomate triturado. Cocer el preparado durante 10 minutos. Reservar. En una cazuela con mucha agua, cocer la pasta durante 8 minu-tos, escurrirla y verterla a la sartén. Añadir el queso de oveja rallado y amalgamar.
Emplatado: Servir caliente en plato llano, espol-vorear con ralladura de queso y adornar con unas loncha de tocino.

# Osteria dell'Ingegno

Design: Marco Dimiziani, Giacomo Nitti I Chef: Massimo Villella

Piazza di Pietra 45 I 00186 Rome
Phone: +39 06 6780662
Opening hours: Mon–Sun 1 pm to 3:30 pm, 7:30 pm to midnight
Average price: € 35–50
Cuisine: Elegant traditional Italian cuisine, seasonal ingredients
Special features: Restaurant located in one of Rome's most beautiful piazzas

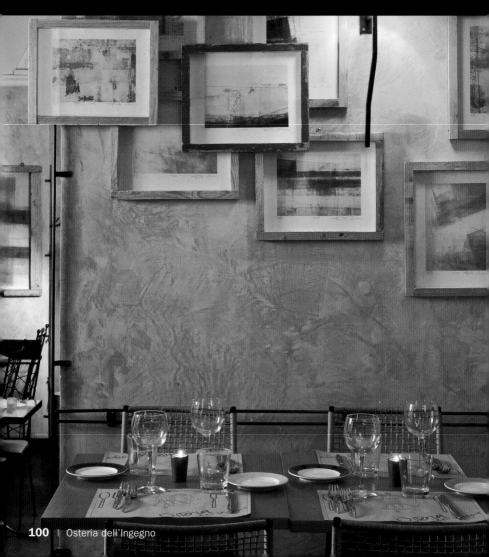

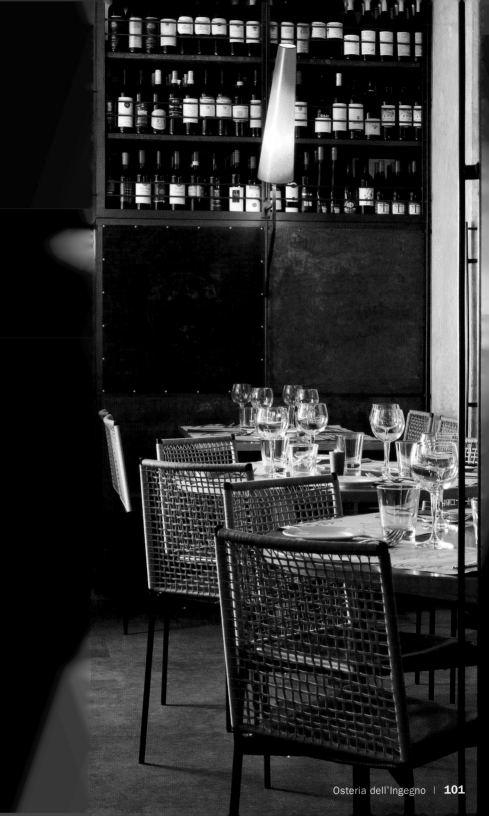

# Cuscùs di pesce

Fish Couscous
Couscous mit Fisch
Couscous de poisson
Cuscús de pescado

200 g semola di grano
200 g di cozze
200 g di vongole
500 g di pesce di scoglio (triglia, scorfano, grongo, pesce cappone) pulito
200 ml di olio di oliva
150 ml di vino bianco
50 ml di salsa di pomodoro
1 rametto di timo
1 peperoncino rosso
1 chiodo di garofano
1 limone

Cuocere al vapore la semola con il chiodo di garofano e la scorza di mezzo limone per 25 minuti. Ritirare dal fuoco e mettere da parte. In una padella grande, soffriggere il timo e il peperoncino rosso. Aggiungere le cozze e le vongole e attendere fino a che non si schiudano. A quel punto unire il pesce di scoglio, cospargere di vino e salsa di pomodoro e far cuocere per 7 minuti.
Presentazione: In un vassoio allungato, ad un'estremità sistemare la semola formando un piccolo monticello. Bagnarlo con la salsa del pesce e coronarlo con le vongole e le cozze. All'altra estremità, sistemare il pesce di scoglio. Spolverizzare con la scorza grattugiata di mezzo limone e decorare con timo fresco.

7 oz semolina wheat
7 oz mussels
7 oz clams
18 oz rock fish (red mullet, scorpionfish, conger eel, tub gurnard), cleaned
200 ml olive oil
150 ml white wine
50 ml tomato sauce
1 sprig thyme
1 red chili
1 clove
1 lemon

Steam the semolina with the clove and the rind of a half lemon for 25 minutes. Remove and set aside. In a large skillet, sauté the thyme and the red chili. Add the mussels and clams and wait until they open. Then add the rock fish, drizzle with wine and tomato sauce, and cook for 7 minutes.
Presentation: Using a long platter, place the semolina on one end, making a small mound. Pour the fish sauce over it and top with the clams and mussels. Place the rock fish on the other end. Sprinkle with the grated rind of a half lemon and garnish with fresh thyme.

200 g Weizengrieß
200 g Miesmuscheln
200 g Venusmuscheln
500 g Tiefseefische (Meerbarbe, Drachenkopf,
Seeaal, roter Knurrhahn), gereinigt
200 ml Olivenöl
150 ml Weißwein
50 ml Tomatensoße
1 Thymianzweig
1 rote Chilischote
1 Gewürznelke
1 Zitrone

Den Grieß mit der Gewürznelke und der Schale einer halben Zitrone 25 Minuten im Dampf garen, abtropfen lassen und beiseite stellen. In einer großen Pfanne den Thymian und die Chilischote anbraten. Die Miesmuscheln und Venusmuscheln hinzugeben und warten bis sie sich öffnen. Die verschiedenen Fischfilets dazulegen, mit Wein und Tomatensoße übergießen und 7 Minuten kochen lassen.
Servieren: Den Grieß am äußersten Ende einer länglichen Servierschale zu kleinen Häufchen formen, die Fischsoße dazugießen und mit den Muscheln krönen. Auf der anderen Seite den Fisch drapieren, mit den Raspeln der Schale einer halben Zitrone bestreuen und frischem Thymian verzieren.

---

200 g de semoule de blé
200 g de moules
200 g de palourdes
500 g de poissons de roches (rouget, rascasse,
congre, grondin) préparés
200 ml d'huile d'olive
150 ml de vin blanc
50 ml de sauce tomate
1 branche de thym
1 chili rouge
1 clou de girofle
1 citron

Cuire la semoule à la vapeur avec le clou de girofle et le zeste d'un demi citron durant 25 minutes. Retirer et réserver. Dans une grande poêle, faire revenir le thym et le chili rouge. Ajouter les moules et les palourdes et attendre qu'elles s'ouvrent. Ajouter alors les poissons de roches, arroser de vin et de sauce tomate puis laisser cuire 7 minutes.
Présentation : Dans un plat allongé, disposer à une extrémité la semoule en formant un petit monticule. La baigner de la sauce de poisson et la couronner des moules et des palourdes. À l'autre extrémité, disposer les poissons de roches. Saupoudrer du zeste râpé d'un demi citron et décorer avec le thym frais.

---

200 g sémola de trigo
200 g de mejillones
200 g de almejas
500 g de pescado de roca (salmonete, rascacio, congrio, bejel) limpio
200 ml de aceite de oliva
150 ml de vino blanco
50 ml de salsa de tomate
1 ramita de tomillo
1 guindilla
1 clavo de olor
1 limón

Cocer al vapor la sémola con el clavo de olor y la cáscara de medio limón durante 25 minutos. Retirar y reservar. En una sartén grande, sofreír el tomillo y la guindilla. Añadir los mejillones y las almejas y esperar a que se abran. Echar entonces el pescado de roca, rociar con vino y salsa de tomate y dejar cocer durante 7 minutos.
Emplatado: En una fuente alargada, colocar en un extremo la sémola formando un pequeño montículo. Bañarla con la salsa del pescado y coronarla con las almejas y los mejillones. En el otro extremo colocar el pescado de roca. Espolvorear con ralladura de cáscara de medio limón y adornar con tomillo fresco.

# RED Restaurant & Design

Design: Stefano Mazzarelli I Chef: Umberto Arcioni

Via P. de Coubertin 30 I 00196 Roma
Phone: +39 06 80691630
Opening hours: Mon–Sun noon to midnight
Average price: € 40
Cuisine: Modern Italian cuisine with seasonal ingredients
Special features: The menu changes completely every two months. The restaurant is located in the new music hall complex

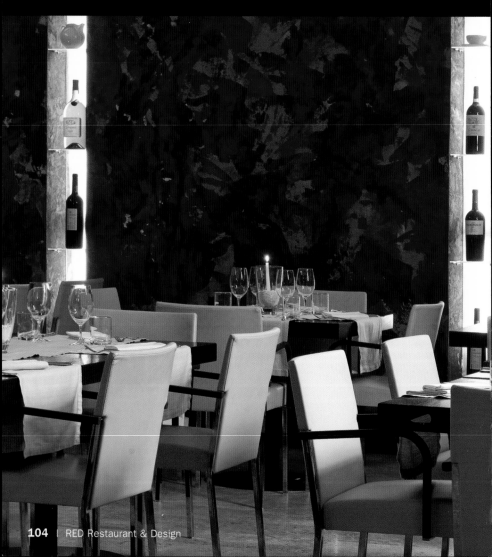

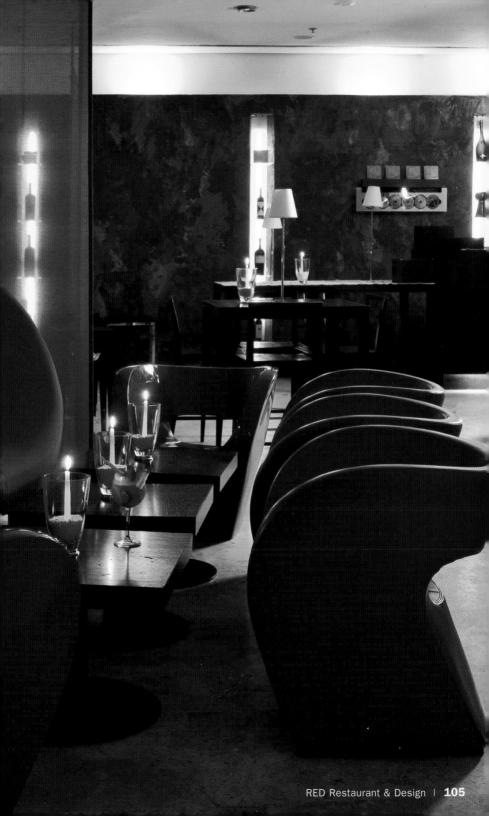

# Tonno rosso

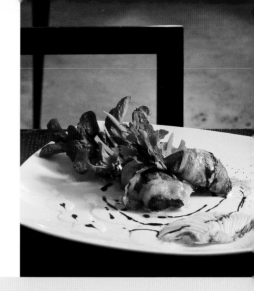

Red Tuna
Roter Thunfisch
Thon rouge
Atún rojo

200 g di filetti di tonno
40 g di pancetta a fette
1 pera tagliata a forma di ventaglio
20 g di formaggio di pecora grattugiato
50 ml di latte
20 ml di aceto balsamico
1 lattuga foglia di quercia
1 carota
1 rucola

Fare a pezzi i filetti di tonno tagliandoli in diago-
nale e avvolgere ogni pezzo con una fetta di pan-
cetta. Tagliare la pera a fette sottili e disporle su
una teglia da forno assieme ai pezzi di tonno. In-
fornare per 7 minuti a 180 °C. Nel frattempo, far
bollire in un pentolino il latte con il formaggio.
Presentazione: Coprire il fondo di un vassoio
con la salsa di latte e formaggio, disporre i pez-
zi di tonno al centro e le fettine di pera in un an-
golo. Cospargere di aceto balsamico e decorare
con rucola, lattuga foglia di quercia e carota ta-
gliata a julienne.

7 oz tuna fillets
1 1/3 oz sliced bacon
1 pear cut in a fan shape
2/3 oz grated sheep milk cheese
50 ml milk
20 ml balsamic vinegar
1 oak lettuce leaf
1 carrot
1 arrugula

Cut the tuna fillets into pieces on the diagonal
and wrap each piece in a slice of bacon. Slice
the pear and arrange the slices in an ovenproof
dish with the tuna. Bake for 7 minutes at 350 °F.
Meanwhile, boil the milk and cheese in a small
saucepan.
Presentation: Cover the bottom of a platter with
the milk-and-cheese sauce, arrange the tuna in
the center and the pear slices in one corner.
Drizzle with balsamic vinegar and garnish with
arrugula, lettuce, and julienned carrot.

200 g Thunfischfilets
40 g Speck in Scheiben
1 Birne, fächerförmig geschnitten
20 g geriebener Schafskäse
50 ml Milch
20 ml Balsamico-Essig
1 Blatt Eichblattsalat
1 Karotte
1 Rucolasalat

Thunfischfilets in diagonale Stücke schneiden und jedes einzelne in eine Scheibe Speck einrollen. Die Birne in schmale Streifen schneiden, so dass ein Fächer entsteht und mit dem Thunfisch auf einem ofenfesten Teller anrichten. Im Ofen 7 Minuten lang bei 180 °C backen. Währenddessen Milch und Käse in einem kleinen Topf erhitzen.
Servieren: Den Boden eines Serviertellers mit der Milch-Käse-Soße bedecken, die Thunfischfilets in der Mitte platzieren und die Birne fächerförmig in einer Ecke drapieren. Mit Balsamico-Essig begießen und Rucolasalat, Eichblattsalat und die kleingeschnittene Karotte ringsherum anordnen.

200 g de filets de thon
40 g de lard en tranches
1 poire coupée en éventail
20 g de fromage de chèvre râpé
50 ml de lait
20 ml de vinaigre balsamique
1 laitue de feuille de chêne
1 carotte
1 roquette

Couper les filets de thon en diagonale et envelopper chaque morceau d'une tranche de lard. Couper la poire en tranches fines et les disposer sur un plat à gratin avec le thon. Passer 7 minutes au four à 180 °C. Pendant ce temps, faire bouillir dans une casserole le lait avec le fromage.
Présentation : Couvrir le fond d'un plat creux avec la sauce au lait et fromage, disposer les morceaux de thon au centre et les tranches de poire dans un angle. Arroser de vinaigre balsamique et décorer avec la roquette, la feuille de chêne et une julienne de carotte

200 g de filetes atún
40 g de tocino en lonchas
1 pera cortada en forma de abanico
20 g de queso de oveja rallado
50 ml de leche
20 ml vinagre balsámico
1 lechuga hoja de roble
1 zanahoria
1 rúcula

Trocear los filetes de atún cortándolos en diagonal y envolver cada trozo con una loncha de tocino. Cortar la pera en láminas y disponerlas sobre una fuente de horno con los trozos de atún. Hornear durante 7 minutos a 180 °C. Mientras, hervir en un cazo la leche con el queso.
Emplatado: Cubrir el fondo de una fuente con la salsa de leche y queso, disponer los trozos de atún en el centro y las láminas de pera en una esquina. Rociar con vinagre balsámico y adornar con rúcula, lechuga hoja de roble y zanahoria cortada en juliana.

# Retrozerodue

Design: P+R+V Architetti I Chef: Norma Moroni

Via dei Colli Portuensi 172–174 I 00151 Rome
Phone: +39 06 53273530
Subway: Ostiense
Opening hours: Mon–Sun 8 pm to 1 am
Average price: € 20
Cuisine: Italian cuisine with traditional products
Special features: Italian specialty store and wine cellar

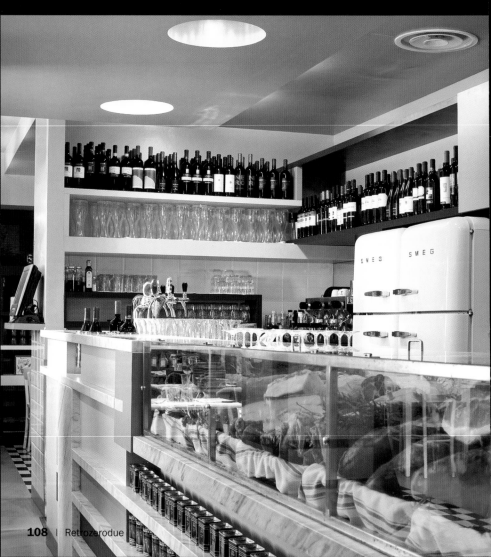

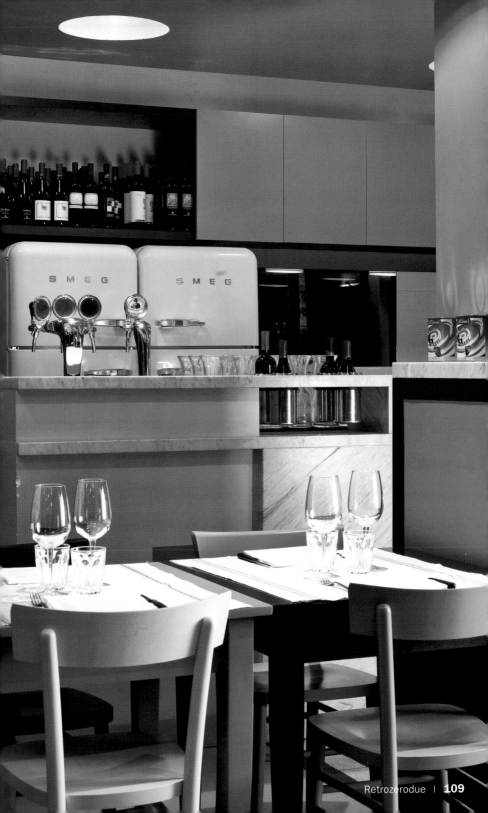

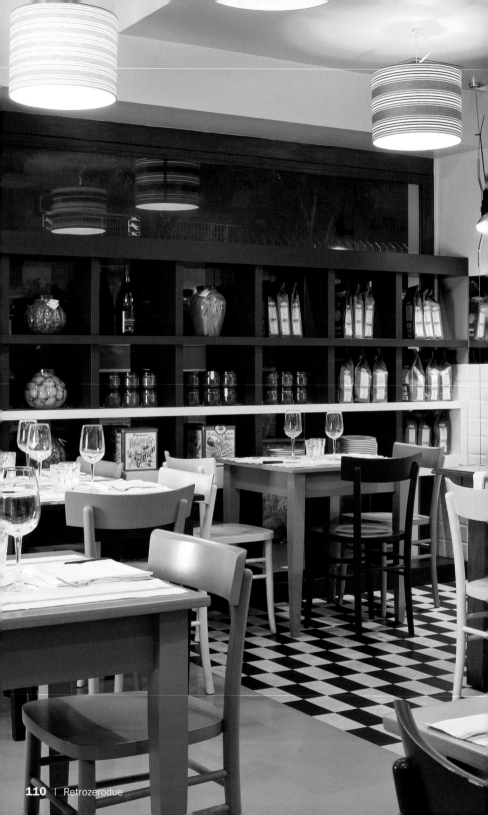

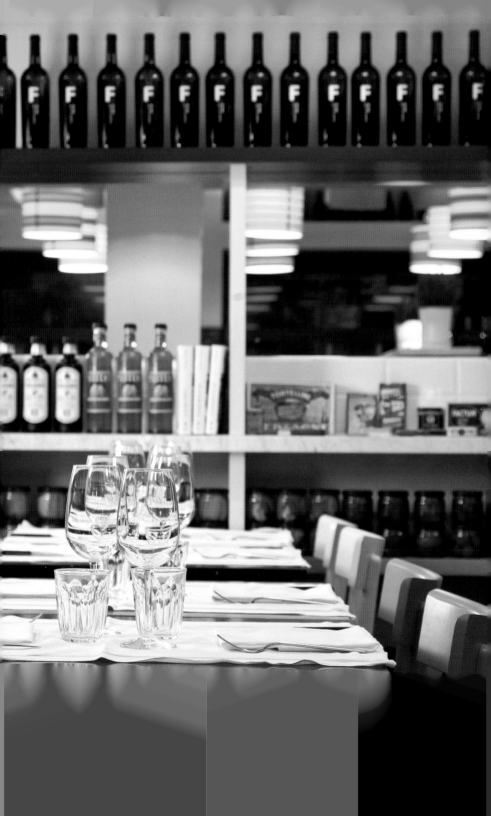

# Trippa
## alla romana

Tripe a la Romana
Kutteln a la Romana
Tripes à la romaine
Callos a la romana

1 kg di trippa di vitello
1 carota
1 gambo di sedano
2 cipolle
50 g di pancetta
200 g di formaggio di pecora grattugiato
1 peperoncino rosso
800 g di pomodori pelati
10 g di maggiorana
10 foglie di basilico fresco
5 g di pepe nero macinato
300 ml d'acqua

In una casseruola con acqua e sale, far bollire la trippa con una cipolla intera e mezzo gambo di sedano per 40 minuti. Togliere la trippa e tagliarla a strisce sottili. In un'altra casseruola con dell'olio di oliva, soffriggere per 5 minuti una cipolla tritata, il sedano restante, la pancetta tagliata a dadini, la maggiorana e il peperoncino rosso. Quindi unire il pomodoro triturato, l'acqua e delle foglie di menta. Far cuocere per 30 minuti. In ultimo, aggiungere la trippa e cuocere per altri 10 minuti.
Presentazione: Servire caldo in un piatto piano, spolverizzare con il formaggio di pecora e il pepe nero; adornare con delle foglie di basilico.

3 lb 3 oz beef tripe
1 carrot
1 celery stalk
2 onions
3/4 oz bacon
7 oz grated sheep's milk cheese
1 red chili
1 lb 12 oz crushed tomatoes
1/3 oz marjoram
10 fresh basil leaves
1/6 oz ground black pepper
300 ml water

In a pot with salted water, boil the tripe with a whole onion and half a celery stalk for 40 minutes. Remove the tripe and cut into thin strips. In another pot, with olive oil, sauté one chopped onion, the remaining celery, the bacon (cut into squares), the marjoram, and the chili for 5 minutes. Then add the crushed tomato, the water, and a few mint leaves. Cook for 30 minutes. Finally, add the tripe and cook 10 minutes more.
Presentation: Serve warm on a flat plate, sprinkle with sheep's milk cheese and black pepper, and garnish with basil leaves.

1 kg Rinderkutteln
1 Karotte
1 Selleriestange
2 Zwiebeln
50 g Speck
200 g geriebener Schafskäse
1 rote Chilischote
800 g pürierte Tomaten
10 g Majoran
5 kg gemahlene schwarze Pfefferkörner
Einige Pfefferminzblätter
Einige Basilikumblätter
300 ml Wasser

Die Kutteln mit Wasser, Salz, einer ganzen Zwiebel und einer halben Selleriestange in einer Kasserolle 40 Minuten lang kochen. Die Kutteln herausnehmen und in hauchdünne Streifen schneiden. Eine feingehackte Zwiebel, den Rest der Selleriestange, den gewürfelten Speck, Majoran und die Chilischote 5 Minuten in einer Pfanne mit Olivenöl anbraten. Die pürierten Tomaten, Wasser und die Pfefferminzblätter dazugeben. Diese Mischung 30 Minuten kochen lassen, danach die Kutteln hinzufügen und weitere 10 Minuten kochen lassen.
Servieren: Heiß auf einem flachen Teller servieren, den Käse und schwarzen Pfeffer darüber streuen und mit einigen Basilikumblättern verzieren.

1 kg de tripes de bœuf
1 carotte
1 branche de céleri
2 oignons
50 g de lard
200 g de fromage de chèvre râpé
1 chili rouge
800 g de tomates concassées
10 g de marjolaine
10 feuilles de basilic frais
5 g de poivre noir moulu
300 ml d'eau

Dans une casserole avec de l'eau et du sel, faire bouillir les tripes avec un oignon entier et une demi branche de céleri pendant 40 minutes. Sortir les tripes et les détailler en fines lanières. Dans une autre casserole avec de l'huile d'olive, faire sauter 5 minutes un oignon haché, le reste du céleri, le lard coupé en dés, la marjolaine et le chili. Ajouter ensuite les tomates concassées, l'eau et quelques feuilles de menthe. Faire cuire 30 minutes. Enfin, ajouter les tripes et faire cuire 10 minutes de plus.
Présentation : servir chaud dans un plat de service, saupoudrer de fromage de chèvre et de poivre noir et décorer avec quelques feuilles de basilic.

1 kg de tripa de ternera
1 zanahoria
1 rama de apio
2 cebollas
50 g de tocino
200 g de queso de oveja rallado
1 guindilla
800 g de tomate triturado
10 g de mejorana
10 hojas de albahaca fresca
5 g de pimienta negra molida
300 ml de agua

En una cazuela con agua y sal, hervir la tripa con una cebolla entera y media rama de apio durante 40 minutos. Retirar la tripa y cortarla en tiras sutiles. En otra cazuela con aceite de oliva, sofreír durante 5 minutos una cebolla picada, el apio restante, el tocino cortado en dados, la mejorana y la guindilla. Agregar luego el tomate triturado, el agua y unas hojas de menta. Cocer durante 30 minutos. Por último, añadir los callos y cocer durante 10 minutos más.
Emplatado: Servir caliente en plato llano, espolvorear con el queso de oveja y la pimienta negra, y adornar con unas hojas de albahaca.

# Room

### Chef: Luca Visicchio

Via Lucullo 9 | 00187 Rome
Phone: +39 06 42020434
Subway: Barberini
www.roomrestaurant.it
Opening hours: Mon–Fri 12:30 pm to 3:30 pm, 7:30 pm to 12:30 am,
Sat–Sun 7:30 pm to 12:30 am
Average price: € 30–35
Cuisine: Cuisine from every continent
Special features: Interesting sushi-based appetizers on Sundays

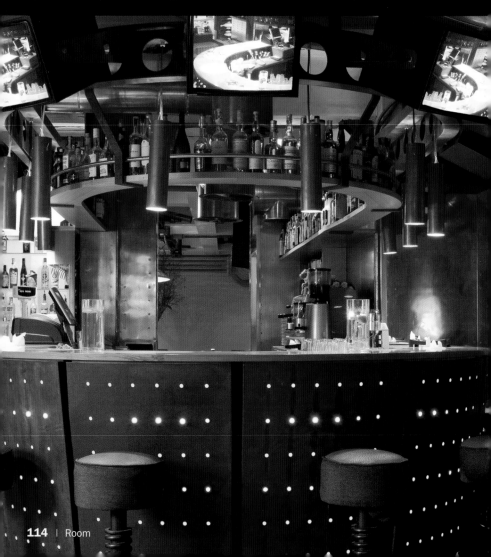

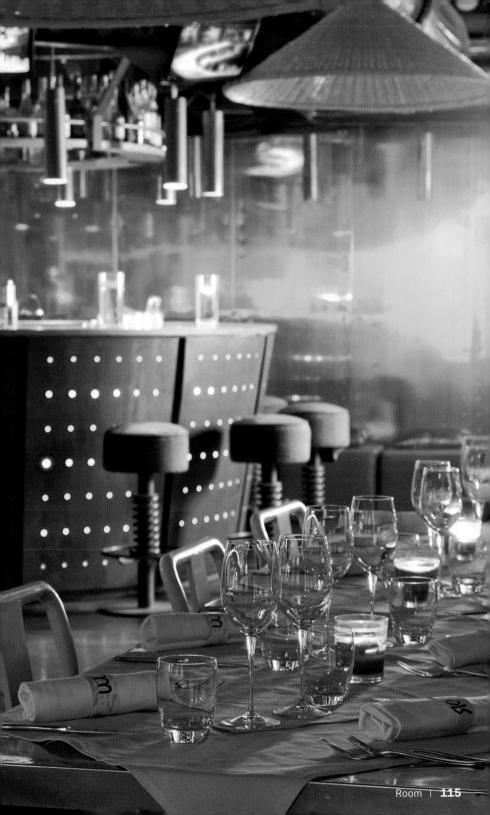

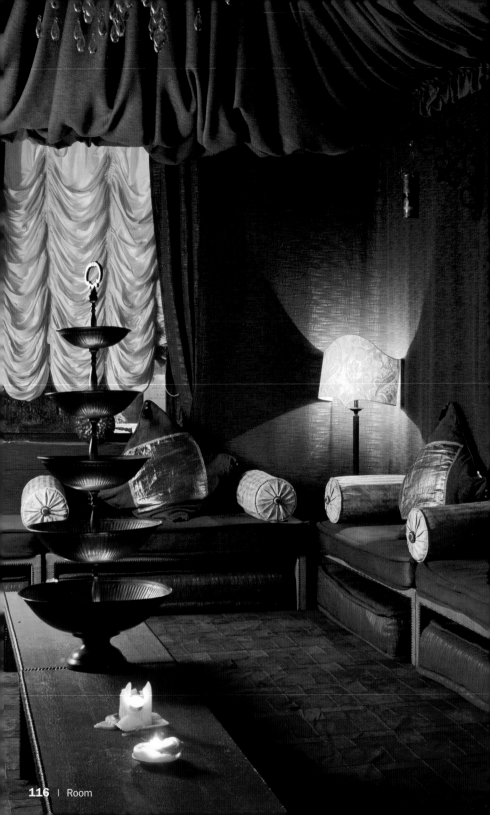

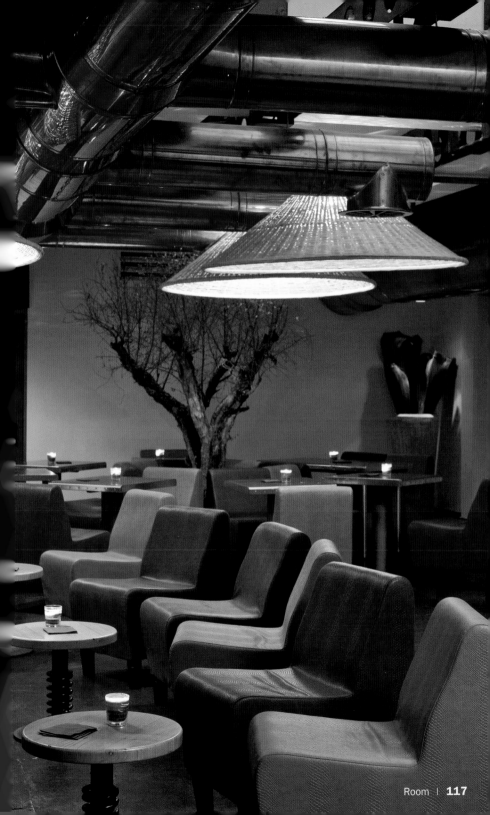

# Vitello farcito

Stuffed Beef
Gefüllte Rinderlende
Bœuf farci
Ternera rellena

200 g di lombata di vitello
25 g di funghi porcini
50 g di patate cotte
10 g di parmigiano grattugiato
10 g di prezzemolo tritato
1/4 di spicchio d'aglio
150 ml di olio extra vergine di oliva
100 ml di brodo di arrosto di vitello
4 pomodori ramati
1 melanzana
1 rametto di rosmarino

Tagliare le patate cotte e i funghi a dadi. In una padella con dell'olio di oliva, soffriggere i funghi assieme all'aglio e al prezzemolo per 5 minuti. Mescolare il soffritto con i dadi di patate e cospargere di prezzemolo e formaggio grattugiato.

Lasciare raffreddare, dopodiché tritare finemente e mettere da parte. Appiattire la lombata fino a uno spessore di mezzo centimetro, al centro disporvi il ripieno ed avvolgere a forma di pera. Una volta farcita la lombata, collocarla in una teglia da forno, unire il preparato di patate, funghi e prezzemolo e cuocere al forno per 13 minuti a 180 °C. Lasciare a riposo. Tagliare la melanzana e il pomodoro a rondelle e condire con olio di oliva. In una teglia da forno, disporre le verdure a forma di rosa, alternando una rondella di melanzana e una di pomodoro. Infornare per 5 minuti a 160 °C.
Presentazione: Sistemare la rosa di verdure al centro del piatto e in mezzo la pera di vitello tagliata in tre parti. Bagnare con il brodo di vitello e decorare con un rametto fritto di rosmarino.

7 oz beef steak
1 oz boletus edulis mushrooms
3/4 oz cooked potatoes
1/3 oz grated Parmesan
1/3 oz chopped parsley
1/4 clove of garlic
150 ml extra virgin olive oil
100 ml roast beef stock
4 fresh tomatoes
1 eggplant
1 sprig of rosemary

Cut the cooked potatoes and the boletus mushrooms into squares. In a skillet with olive oil, sauté the mushrooms with garlic and parsley for 5 minutes. Combine the sautéed mixture with

the potato squares and sprinkle with parsley and grated cheese. Let cool, then chop finely and set aside. Flatten the meat to a thickness of 1/5 inches, place the filling in the center, and roll into a pear shape. Place the stuffed meat in an ovenproof dish, add the potato mixture, and bake for 13 minutes at 350 °F. Set aside. Slice the eggplant and tomato and drizzle with olive oil. In an ovenproof dish, arrange the vegetables in a rose pattern, alternating slices of eggplant and tomato. Bake at 320 °F for 5 minutes. Presentation: Place the vegetables arranged in the rose pattern in the center of the platter and, in the middle, the stuffed meat, which has been cut in three. Pour the beef stock over all and garnish with a sprig of fried rosemary.

200 g Rinderlende
25 g Steinpilze
50 g gekochte Kartoffeln
10 g geriebener Parmesan
10 g gehackte Petersilie
1/4 Knoblauchzehe
150 ml Olivenöl Extra Vergine
100 ml Rinderbratensoße
4 Strauchtomaten
1 Aubergine
1 Rosmarinzweig

Die geschälten Kartoffeln und die Steinpilze würfeln. Die Pilze mit Knoblauch und Petersilie 5 Minuten lang in einer Pfanne mit Olivenöl anbraten. Das Angebratene mit den Kartoffelwürfeln vermengen und mit Petersilie sowie geriebenem Käse bestreuen. Abkühlen lassen, zerkleinern und beiseite stellen. Die Rinderlende auf eine Dicke von einem halben Zentimeter flach klopfen, die Füllung in der Mitte platzieren und birnenförmig zusammenrollen. Die gefüllte Rinderlende mit der Kartoffel-Pilz-Mischung in eine Auflaufform geben und 13 Minuten lang bei 180 °C backen. Beiseite stellen. Aubergine und Tomaten in Scheiben schneiden und Olivenöl hinzugeben. Auberginen- und Tomatenscheiben abwechselnd in Rosenform auf eine ofenfeste Servierplatte legen und 5 Minuten lang bei 160 °C backen.
Servieren: Die Gemüserose in der Mitte des Tellers platzieren und darauf das in drei Teile geschnittene Fleisch legen. Abschließend die Rinderbratensoße darüber gießen und mit einem angebratenen Rosmarinzweig garnieren.

---

200 g d'aloyau de bœuf
25 g de bolets
50 g de pommes de terre cuites
10 g de parmesan râpé
10 g de persil haché
1/4 de pointe d'ail
150 ml d'huile d'olive vierge
100 ml de bouillon de bœuf braisé
4 tomates en branche
1 aubergine
1 brin de romarin

Couper les pommes de terre cuites et les bolets en dés. Dans une poêle avec l'huile d'olive, faire sauter les champignons avec l'ail et le persil pendant 5 minutes. Mélanger avec les pommes de terre et saupoudrer de persil et de fromage râpé. Laisser refroidir puis hacher finement et réserver. Aplatir l'aloyau pour atteindre une épaisseur d'un demi centimètre, disposer la farce en son centre et enrouler en forme de poire. Placer l'aloyau farci dans un moule à gratin, ajouter la préparation de pommes de terre, de champignons et de persil et passer 13 minutes au four à 180 °C. Réserver. Couper l'aubergine et les tomates en tranches et assaisonner avec l'huile d'olive. Dans un plat creux, disposer les légumes en forme de rose, en faisant alterner les tranches de tomate et d'aubergine. Passer 5 minutes au four à 160 °C.
Présentation : Disposer la rose de légumes au centre du plat avec en son cœur la poire d'aloyau en trois parties. Baigner du bouillon de bœuf et décorer avec un brin de romarin frit.

---

200 g de lomo de ternera
25 g de boletus edulis
50 g de patatas cocidas
10 g de parmesano rallado
10 g de perejil picado
1/4 de diente de ajo
150 ml de aceite virgen extra
100 ml de caldo de asado de ternera
4 tomates de rama
1 berenjena
1 ramita de romero

Cortar las patatas cocidas y los boletus en dados. En una sartén con aceite de oliva, sofreír las setas con ajo y perejil durante 5 minutos. Mezclar el sofrito con los dados de patatas y espolvorerar con perejil y queso rallado. Dejar enfriar, luego picar finamente y reservar. Majar el lomo hasta un espesor de medio centímetro, colocar en el centro el relleno y enrollar en forma de pera. Poner el lomo relleno en una fuente de horno, agregar el preparado de patatas, setas y perejil y hornear durante 13 minutos a 180 °C. Reservar. Cortar la berenjena y el tomate en rodajas y aliñar con aceite de oliva. En una fuente de horno, disponer las verduras en forma de rosa, alternando una lámina de berenjena y una de tomate. Hornear a 160 °C durante 5 minutos.
Emplatado: Disponer la rosa de verduras en el centro del plato y en medio la pera de lomo cortada en tres partes. Bañar con el caldo de ternera y decorar con una ramita frita de romero.

# Roscioli

Design: Enrico Martini | Chef: Andrea Dolciotti

Via dei Giubbonari 21–23 | 00186 Rome
Phone: +39 06 6875287 / +39 06 68210479
Opening hours: Mon–Sun 12:30 pm to 4 pm, 8 pm to midnight
Average price: € 30
Cuisine: Creative Italian cuisine with traditional ingredients
Special features: This small restaurant and wine cellar is located behind a store that
sells traditionally-prepared Italian specialties

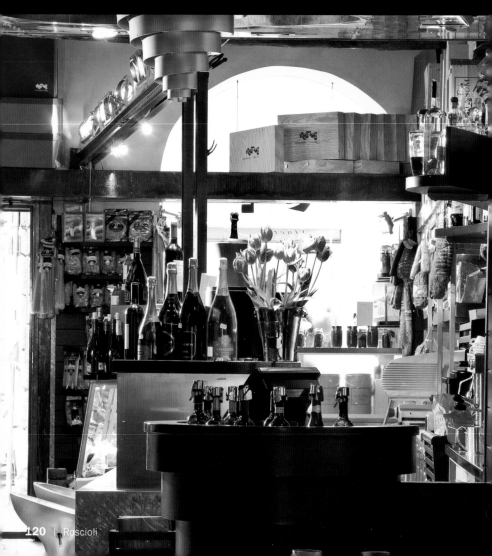

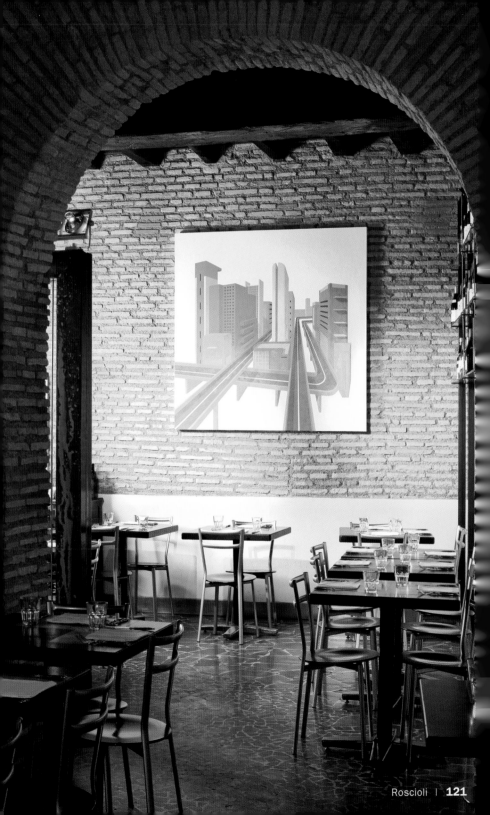

# Lombata di cervo

Loin of Venison

Hirschrücken

Esturgeon et vinaigrette de noisettes

Lomo de ciervo

300 g di lombi di cervo
200 ml di vino rosso
1 rametto di timo
1 rametto di maggiorana
3 foglie di salvia
1 rametto di rosmarino
2 foglie di alloro
50 g di pancetta
1 gambo di sedano
1 carota
1 cipolla
3 patate
50 g di burro

Marinare i lombi di cervo nel vino e nell'alloro, dissossarli e tagliarli a pezzi di circa 100 g. Preparare un trito di timo, maggiorana, salvia, rosmarino e alloro, bagnare i pezzi di lombo nel trito e avvolgerli con la pancetta. In una casseruola, soffriggere il sedano, la carota e la cipolla finemente tritati. Aggiungere la carne, spruzzarvi un po' di vino rosso e far cuocere fino a che non sia dorata. Ritirare dal fuoco, coprire con carta d'alluminio e far cuocere al grill nel forno per 25 minuti. Nel frattempo, in una pentola con acqua e sale, cuocere le patate; quindi dorarle in una padella con un po' di burro.
Presentazione: Filettare i pezzi di lombo e adagiarli su un letto di patate. Adornare con un rametto di rosmarino.

10 1/2 oz loin of venison
200 ml red wine
1 sprig of thyme
1 sprig of marjoram
3 sage leaves
1 sprig of rosemary
2 bay leaves
1 3/4 oz bacon
1 celery stalk
1 carrot
1 onion
3 potatoes
1 3/4 oz butter

Marinate the loins of venison in wine and bay leaves, de-bone and cut into pieces of about 3 1/2 oz each. Prepare a mixture of thyme, marjoram, sage, rosemary, and bay leaves, coat the venison pieces with the mixture, and wrap with bacon. In a pan, sauté the finely-chopped celery, carrot, and onion. Add the venison, drizzle with red wine, and continue to cook until golden brown. Remove from the heat, cover with aluminum foil, and place on the oven grill for 25 minutes. Meanwhile, in a pot with salted water, cook the potatoes; then brown them in a skillet with butter.
Presentation: Fillet the pieces of venison and arrange on a bed of potatoes. Garnish with a sprig of rosemary.

300 g Hirschrücken
200 ml Rotwein
1 Thymianzweig
1 Majoranzweig
3 Salbeiblätter
1 Rosmarinzweig
2 Lorbeerblätter
50 g Speck
1 Selleriestange
1 Karotte
1 Zwiebel
3 Kartoffeln
50 g Butter

Den Hirschrücken mit Wein und Lorbeerblättern marinieren, ausbeinen und in 3 Stücke (jeweils ca. 100 g) schneiden. Eine Mischung aus Thymian, Majoran, Salbei, Rosmarin und Lorbeerblättern zubereiten, die Hirschrückenstücke darin schwenken und diese in einen Speckmantel einrollen. Den Sellerie, die kleingeschnittene Karotte und die zerhackte Zwiebel in einer Pfanne anbraten. Den Hirschrücken dazugeben, mit Rotwein begießen und anbräunen. Vom Feuer nehmen, mit Aluminiumfolie abdecken und im Ofen 25 Minuten lang grillen lassen. Währenddessen die Kartoffeln in einem Topf in Salzwasser kochen und später in einer Pfanne mit Butter anbraten.
Servieren: Die Hirschrückenstücke filetieren und auf einem Kartoffelbett drapieren. Mit einem Rosmarinzweig dekorieren.

---

300 g d'aloyau de cerf
200 ml de vin rouge
1 branche de thym
1 branche de marjolaine
3 feuilles de sauge
1 brin de romarin
2 feuille de laurier
50 g de lard
1 branche de céleri
1 carotte
1 oignon
3 pommes de terre
50 g de beurre

Faire mariner l'aloyau de cerf avec le vin et le laurier, le désosser et le détailler en morceau d'environ 100 g. Préparer un hachis de thym, de marjolaine, de sauge, de romarin et de laurier pour en enrober les morceaux d'aloyau puis les envelopper dans le lard. Dans une casserole, faire sauter le céleri, la carotte et l'oignon finement hachés. Ajouter les morceaux de cerf, arroser de vin rouge et poursuivre la cuisson pour les dorer. Retirer du feu, couvrir de papier aluminium et passer au grill du four pendant 25 minutes. Pendant ce temps, dans une casserole d'eau salée, cuire les pommes de terre et les dorer ensuite à la poêle avec du beurre.
Présentation : Préparer des filets d'aloyau et les disposer sur le lit de pommes de terre. Décorer avec un brin de romarin.

---

300 g de lomo de ciervo
200 ml de vino tinto
1 ramita de tomillo
1 ramita de mejorana
3 hojas de salvia
1 ramita de romero
2 hojas de laurel
50 g de tocino
1 rama de apio
1 zanahoria
1 cebolla
3 patatas
50 g de mantequilla

Marinar los lomos de ciervo en vino y laurel, deshuesarlos y cortarlos en trozos de 100 g aproximadamente. Preparar una picada de tomillo, mejorana, salvia, romero y laurel, rebozar los trozos de lomo en el picado y envolverlos con tocino. En una cazuela, sofreír el apio, la zanahoria y la cebolla finamente picados. Añadir el ciervo, rociar con vino tinto y seguir cociendo hasta que se dore. Retirar del fuego, cubrir con papel de aluminio y meter al grill en el horno durante 25 minutos. Mientras, en una cazuela con agua y sal, cocer las patatas; dorarlas luego en una sartén con mantequilla.
Emplatado: Filetear los trozos de lomo y disponerlos sobre un lecho de patatas. Adornar con un ramillete de romero.

# Santa Lucia

Design: Enrico Martini | Chef: Bartolomeo Cuomo

Largo Febo 12 | 00186 Rome
Phone: +39 06 68802427
www.santalucia-bartolo.com
Opening hours: Mon–Sun noon to 3:30 pm, 7:30 pm to midnight
Average price: € 70
Cuisine: Traditional Italian cuisine, reinterpreted
Special features: In addition to quality cuisine, you can enjoy an interesting collection
of works of art, some of which were gifts from the clients to this famous Roman chef

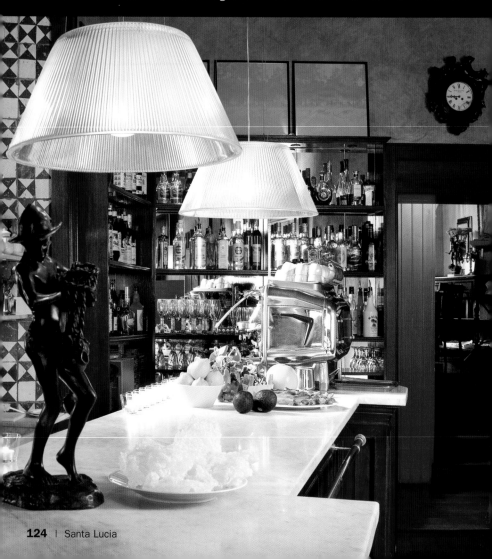

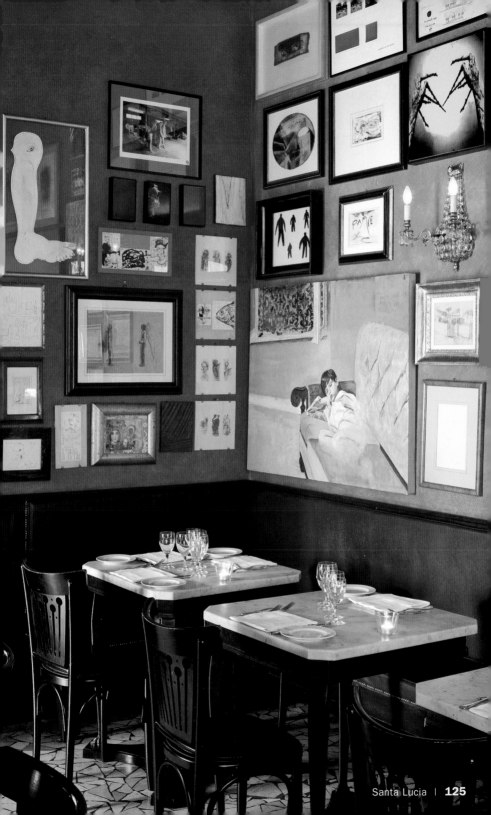

# Tagliatelle

## alla saracena

Saracen Noodles
Tagliatelle nach sarazenischer Art
Pâtes sarrasines
Tallarines sarracenos

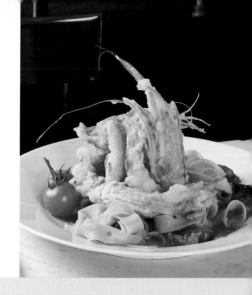

160 g di tagliatelle
6 gamberoni
2 fiori di zucchina
1 rametto di basilico
100 g di pomodorini
1 spicchio d'aglio
200 ml di olio extra vergine di oliva
1 l d'acqua
1 albume d'uovo
80 g di farina
5 grammi di pepe nero in grani

In una casseruola con olio di oliva, soffriggere i pomodori triturati con uno spicchio d'aglio e delle foglie di basilico per 10 minuti. Ritirare dal fuoco e mettere a riposo. In un'altra pentola, portare ad ebollizione abbondante acqua salata, buttare la pasta e far cuocere per 8 minuti. Nel frattempo, montare a neve l'albume dell'uovo e aggiungervi farina ed acqua fino ad ottenere una pastella di un certo spessore. Bagnare i gamberoni e i fiori di zucchina nella pastella e friggerli. Scolare la pasta e mescolarla con la salsa di pomodoro e parte dei gamberoni e dei fiori di zucchina.
Presentazione: Servire caldo in un piatto fondo e adornare con i fiori di zucchina, i restanti gamberoni, e un pomodoro fresco. Cospargere di pepe nero macinato.

5 1/2 oz tagliatelle
6 prawns
2 zucchini flowers
1 sprig of basil
3 1/2 oz small tomatoes
1 clove of garlic
200 ml extra virgin olive oil
1 l water
1 egg white
2 3/4 oz flour
1/6 oz ground black pepper

In a pot with olive oil, sauté the crushed tomatoes with one clove of garlic and a few basil leaves for 10 minutes. Remove and set aside. In a pot, bring a generous amount of salted water to a boil, add the pasta, and cook for 8 minutes. Meanwhile, beat the egg white till foamy and add flour and water until the consistency of thick cream. Coat the prawns and the zucchini flowers with the egg white mixture and fry. Drain the pasta and combine with the tomato sauce and some of the prawns and the zucchini flowers.
Presentation: Serve warm in a deep dish and garnish with the zucchini flowers, the remaining prawns, and a fresh tomato. Sprinkle with ground black pepper.

160 g Tagliatelle
6 Garnelen
2 Zucchiniblüten
1 Basilikumzweig
100 g kleine Tomaten
1 Knoblauchzehe
200 ml Olivenöl Extra Vergine
1 Liter Wasser
1 Eiweiß
80 g Mehl
5 g schwarze Pfefferkörner

Die pürierten Tomaten mit einer Knoblauchzehe und einigen Basilikumblättern in einer Pfanne 10 Minuten lang anbraten. Vom Feuer nehmen und beiseite stellen. Die Nudeln in einem großen Topf mit reichlich Wasser und ein wenig Salz 8 Minuten lang kochen. Währenddessen das Eiweiß zu Eischnee schlagen. Mehl und Wasser hinzugeben, so dass eine dickflüssige Creme entsteht. Garnelen und Zucchiniblüten dieser Creme hinzufügen und zusammen braten. Die Nudeln abgießen und mit der Tomatensoße, den Garnelen und den Zucchinis vermischen. Servieren: In einem tiefen Teller heiß servieren und mit den übrigen Garnelen, Zucchiniblüten und Tomaten garnieren. Abschließend den gemahlenen schwarzen Pfeffer darüber streuen.

160 g de tagliatelles
6 gambons
2 fleurs de courgette
1 brin de basilic
100 g de petites tomates
1 pointe d'ail
200 ml d'huile d'olive vierge extra
1 l d'eau
1 blanc d'œuf
80 g de farine
5 g de poivre noir en grains

Dans une casserole avec de l'huile d'olive, faire revenir les tomates concassées avec une pointe d'ail et quelques feuilles de basilic, durant 10 minutes. Retirer et réserver. Amener une casserole d'eau salée à ébullition, plonger les pâtes et laisser cuire 8 minutes. Pendant ce temps, monter un blanc en neige et ajouter de la farine et de l'eau pour obtenir une crème épaisse. Baigner les gambons et les fleurs de courgette dans la crème et les faire frire. Égoutter les pâtes et les mélanger avec la sauce tomate et une partie des gambons et des fleurs de courgette. Présentation : Servir chaud dans un plat de service creux avec le reste des fleurs de courgette et des gambons et avec une tomate fraîche. Saupoudrer de poivre noir moulu.

160 g de tallarines
6 gambones
2 flores de calabacín
1 ramita de albahaca
100 g de tomates pequeños
1 diente de ajo
200 ml de aceite de oliva virgen extra
1 l de agua
1 clara de huevo
80 g de harina
5 g de pimienta negra en grano

En una cazuela con aceite de oliva, sofreír los tomates triturados con un diente de ajo y unas hojas de albahaca durante 10 minutos. Retirar y reservar. Llevar a ebullición, en una cacerola, abundante agua con sal, echar la pasta y cocer durante 8 minutos. Mientras, montar a punto de nieve la clara de huevo y añadir harina y agua hasta obtener una crema espesa. Rebozar los gambones y las flores de calabacín en la crema y freírlos. Escurrir la pasta y mezclarla con la salsa de tomate y parte de los gambones y de las flores de calabacín. Emplatado: Servir caliente en plato hondo y adornar con las flores de calabacín y los gambones restantes, y con un tomate fresco. Espolvorear con pimienta negra molida.

# Settembrini

Design: Giovanni Pogliani I Chef: Marco Poddi

Via Luigi Settembrini 25 I 00195 Rome
Phone: +39 063232617
Subway: Lepanto
Opening hours: Mon–Sat 1 pm to 3 pm, 8 pm to 11 pm
Average price: € 35
Cuisine: Quality classic Italian cuisine
Special features: The décor is a successful and pleasant modern version of the classic Italian trattoria

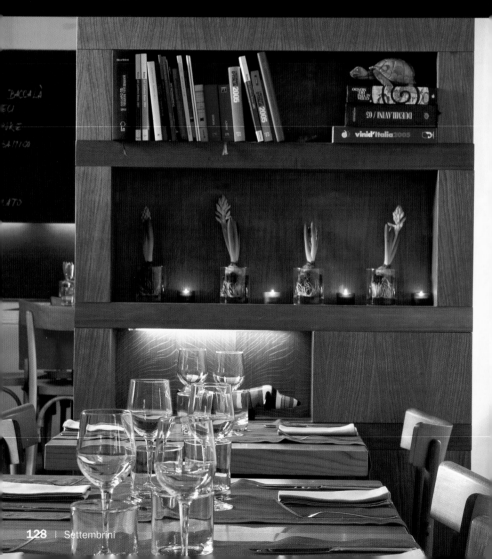

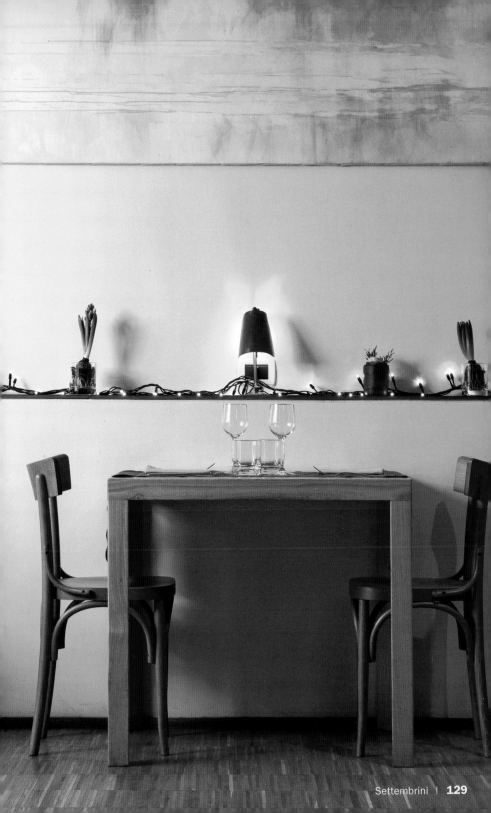

ONDI

AZIONE di BACCALÀ

LIE con i CECI

INO al VAPORE

RA al BALSAMICO

TTO

di CIOCCOLATO

VINI IN MESCITA

Hausmannof '93, HADERBURG   € 8,00

Bellenda mill. '97, BELLENDA   € 8,00

### VINI BIANCHI

LIS '02, LIS NERIS   € 7,00

Virtù Romane '03, TENUTA LE QUINTE   € 5,00

Bianco della CASTELLADA, LA CASTELLADA   € 7,00

Aldiano '03, CANTINA TOLLO   € 5,00

## VINI ROSSI

Tuder, '01, B. Nigolosu   € 7,00

Negroamaro '02, MASSERA MAIME   € 6,00

Primitivo di Manduria '03, PERVINI   € 5,00

LIS NERIS '03, LIS NERI'S   € 7,00

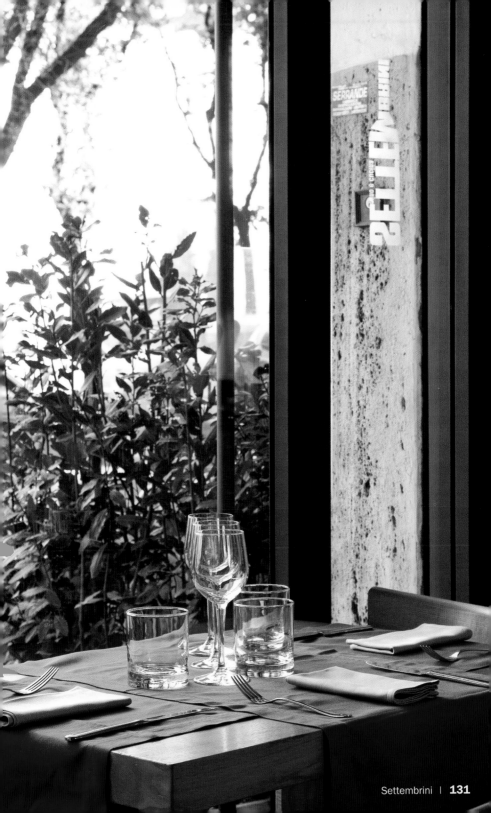

# Triglie ai ceci

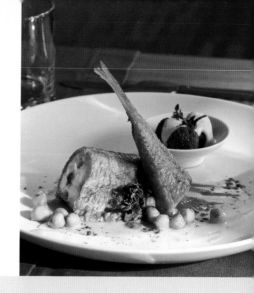

Red Mullets with Chickpeas
Meerbarbe mit Kichererbsen
Rougets aux pois chiches
Salmonetes con garbanzos

2 triglie di 140 g
40 g di ceci cotti
1 cipolla
2 spicchi d'aglio
1 peperoncino rosso
200 ml di vernaccia
200 ml di olio extra vergine di oliva
50 ml di salsa di yogurt
3 crocchette di ceci (falafel)
Timo

Sviscerare e pulire le triglie, tagliarle in due pezzi e friggerle in olio di oliva. In un'altra padella, soffriggere l'aglio, la cipolla tritata e il peperoncino rosso. Unire i ceci e cuocere per 10 minuti. Aggiungere le triglie, bagnare con la vernaccia e far cuocere per altri 10 minuti.
Presentazione: Servire le triglie su una base di salsa di yogurt, spolverizzare con timo e accompagnare con falafel in un recipiente a parte. Decorare con timo.

2 red mullets, 5 oz
1 1/3 oz cooked chickpeas
1 onion
2 cloves of garlic
1 red chili
200 ml vernaccia
200 ml extra virgin olive oil
50 ml yogurt sauce
3 chickpea croquettes (falafel)
Thyme

Gut and clean the red mullets, cut in two, and fry in olive oil. In another skillet, sauté the garlic, chopped onion, and chili. Add the chickpeas and cook for 10 minutes. Add the red mullets, pour garnacha on top, and cook 10 minutes more.
Presentation: Serve the red mullets on a base of yogurt sauce, sprinkle with thyme, and accompany with falafel on a separate plate. Garnish with thyme.

2 Meerbarbe (140 g)
40 g gekochte Kichererbsen
1 Zwiebel
2 Knoblauchzehen
1 rote Chilischote
200 ml Vernaccia
200 ml Olivenöl Extra Vergine
50 ml Joghurtsoße
3 Falafel
Thymian

Meerbarbe ausnehmen und säubern, in zwei Stücke schneiden und in Olivenöl braten. In einer weiteren Pfanne die Knoblauchzehen, die gehackte Zwiebel und die Chilischote anbraten. Die Kichererbsen hinzugeben und 10 Minuten lang kochen lassen. Die Meerbarbe hineingeben, den Wein dazugießen und weitere 10 Minuten kochen.
Servieren: Die Meerbarbe auf die Joghurtsoße betten, den Thymian darüber streuen und getrennt davon die Falafeln reichen.

2 rougets de 140 g
40 g de pois chiches cuits
1 oignon
2 pointes d'ail
1 chili rouge
200 ml de grenache
200 ml d'huile d'olive vierge extra
50 ml de sauce de yaourt
3 croquettes de pois chiches (falafel)
Thym

Vider et nettoyer les rougets, le couper en deux morceaux et les faire frire dans l'huile d'olive. Dans une autre poêle, faire revenir l'ail, l'oignon haché et le chili. Ajouter les pois chiches et faire cuire 10 minutes. Ajouter les rougets, baigner de grenache et poursuivre la cuisson pendant 10 minutes.
Présentation : Servir les rougets sur une base de sauce de yaourt, saupoudrer de thym et accompagner avec les falafels dans un plat à part. Décorer avec thym.

2 salmonetes de 140 g
40 g de garbanzos cocidos
1 cebolla
2 dientes de ajo
1 guindilla
200 ml de garnacha
200 ml de aceite de oliva virgen extra
50 ml de salsa de yogur
3 croquetas de garbanzos (falafel)
Tomillo

Eviscerar y limpiar los salmonetes, cortarlos en dos trozos y freírlos en aceite de oliva. En otra sartén, sofreír el ajo, la cebolla picada y la guindilla. Agregar los garbanzos y cocer durante 10 minutos. Añadir los salmonetes, bañar con la garnacha y dejar cocer durante 10 minutos más.
Emplatado: Servir los salmonetes sobre una base de salsa de yogur, espolvorear con tomillo y acompañar con falafel en un recipiente aparte. Decorar con el tomillo.

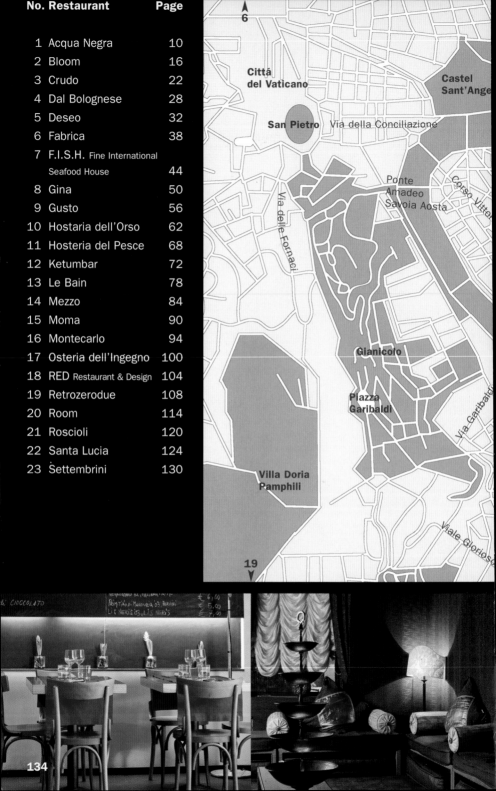

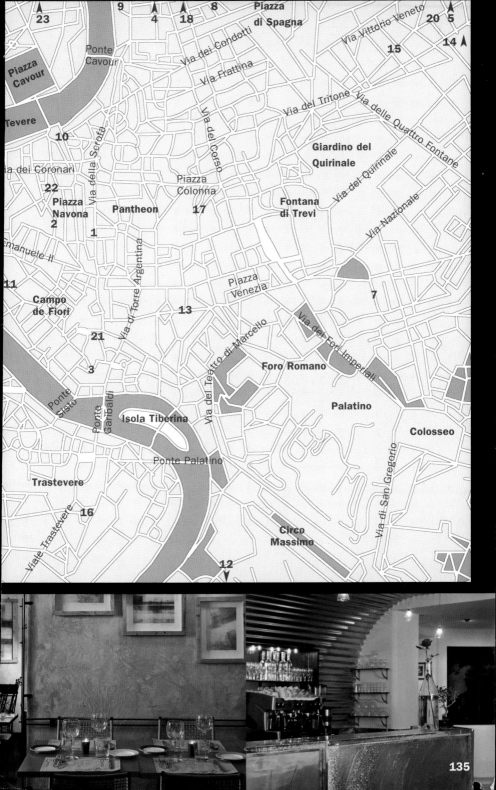

23

9

4 18

8

Piazza
di Spagna

20 5

Ponte
Cavour

Via dei Condotti

Via Vittorio Veneto

14

15

Piazza
Cavour

Via Frattina

Via del Tritone

Via delle Quattro Fontane

Tevere

10

Via del Corso

Giardino del
Quirinale

Via dei Coronari

Via della Scrofa

Piazza
Colonna

Via del Quirinale

22

Piazza
Navona

2

Pantheon

17

Fontana
di Trevi

Via Nazionale

1

Emanuele II

Via di Torre Argentina

Piazza
Venezia

11

Campo
de Fiori

13

7

21

Via del Teatro di Marcello

Via dei Fori Imperiali

3

Foro Romano

Ponte
Sisto

Ponte
Garibaldi

Isola Tiberina

Palatino

Colosseo

Ponte Palatino

Trastevere

Via di San Gregorio

16

Viale Trastevere

Circo
Massimo

12

# Cool Restaurants

Size: 14 x 21.5 cm / 5 1/2 x 8 1/2 in.
136 pp
Flexicover
c. 130 color photographs
Text in English, German, French,
Spanish and (*) Italian / (**) Dutch

Other titles in the same series:

**Amsterdam** (*)
ISBN 3-8238-4588-8

**Milan** (*)
ISBN 3-8238-4587-X

**Barcelona** (*)
ISBN 3-8238-4586-1

**Munich** (*)
ISBN 3-8327-9019-5

**Berlin** (*)
ISBN 3-8238-4585-3

**New York**
ISBN 3-8238-4571-3

**Brussels** (**)
ISBN 3-8327-9065-9

**Paris**
ISBN 3-8238-4570-5

**Chicago** (*)
ISBN 3-8327-9018-7

**Prague** (*)
ISBN 3-8327-9068-3

**Côte d'Azur** (*)
ISBN 3-8327-9040-3

**San Francisco** (*)
ISBN 3-8327-9067-5

**Hamburg** (*)
ISBN 3-8238-4599-3

**Shanghai** (*)
ISBN 3-8327-9050-0

**London**
ISBN 3-8238-4568-3

**Sydney** (*)
ISBN 3-8327-9027-6

**Los Angeles** (*)
ISBN 3-8238-4589-6

**Tokyo** (*)
ISBN 3-8238-4590-X

**Madrid** (*)
ISBN 3-8327-9029-2

**Vienna** (*)
ISBN 3-8327-9020-9

**Miami** (*)
ISBN 3-8327-9066-7

**Zurich** (*)
ISBN 3-8327-9069-1

To be published in the
same series:

Cape Town
Geneva
Hong Kong

Moscow
Stockholm

# teNeues